ARTAUD THE MOMA

COLUMBIA THEMES IN PHILOSOPHY,
SOCIAL CRITICISM, AND THE ARTS

LYDIA GOEHR AND GREGG M. HOROWITZ, EDITORS

ADVISORY BOARD

Carolyn Abbate

J. M. Bernstein

Eve Blau

T. J. Clark

Arthur C. Danto

John Hyman

Michael Kelly

Paul Kottman

Columbia Themes in Philosophy, Social Criticism, and the Arts presents monographs, essay collections, and short books on philosophy and aesthetic theory. It aims to publish books that show the ability of the arts to stimulate critical reflection on modern and contemporary social, political, and cultural life. Art is not now, if it ever was, a realm of human activity independent of the complex realities of social organization and change, political authority and antagonism, cultural domination and resistance. The possibilities of critical thought embedded in the arts are most fruitfully expressed when addressed to readers across the various fields of social and humanistic inquiry. The idea of philosophy in the series title ought to be understood, therefore, to embrace forms of discussion that begin where mere academic expertise exhausts itself; where the rules of social, political, and cultural practice are both affirmed and challenged; and where new thinking takes place. The series does not privilege any particular art, nor does it ask for the arts to be mutually isolated. The series encourages writing from the many fields of thoughtful and critical inquiry.

For a complete list, see page 95.

ARTAUD THE MOMA

INTERJECTIONS OF APPEAL

JACQUES DERRIDA

TRANSLATED BY
PEGGY KAMUF

EDITED, WITH AN AFTERWORD BY
KAIRA M. CABAÑAS

Columbia University Press *New York*

Columbia University Press
Publishers Since 1893
New York Chichester, West Sussex
cup.columbia.edu

Columbia University Press extends its appreciation for the support of the University of Florida College of the Arts and Center for the Humanities and the Public Sphere (Rothman Endowment).
Artaud le Moma copyright © 2002 Editions Galilée
Copyright © 2017 Columbia University Press

All rights reserved
Library of Congress Cataloging-in-Publication Data
Names: Derrida, Jacques, author. | Kamuf, Peggy, 1947– translator. | Cabañas, Kaira Marie, 1974– editor. | Translation of: Derrida, Jacques. Artaud le Moma.
Title: Artaud the Moma: interjections of appeal / Jacques Derrida; translated by Peggy Kamuf; edited, with an afterword by Kaira M. Cabañas.
Other titles: Artaud le Moma. English
Description: New York: Columbia University Press, 2017. | Series: Columbia themes in philosophy, social criticism, and the arts |
Includes bibliographical references.
Identifiers: LCCN 2017011391 | ISBN 9780231181662 (cloth: alk. paper) | ISBN 9780231181679 (pbk.: alk. paper) | ISBN 9780231543705 (e-book)
Subjects: LCSH: Artaud, Antonin, 1896–1948—Criticism and interpretation.
Classification: LCC NC248.A72 D4717513 2017 | DDC 792.02/8092—dc23
LC record available at https://lccn.loc.gov/2017011391

Columbia University Press books are printed on permanent and durable acid-free paper.
Printed in the United States of America

Cover design: Julia Kushnirsky
Cover image: ©CNAC/MNAM/Dist. RMN-Grand Palais / Art Resource, NY

To the memory of Paule Thévenin

CONTENTS

Preface ix

Artaud the Moma 1

Afterword 79
KAIRA M. CABAÑAS

Notes 87

Acknowledgments 93
KAIRA M. CABAÑAS

PREFACE

This lecture was delivered on October 16, 1996, at the Museum of Modern Art in New York, for the opening of the first large worldwide exhibition of the paintings and drawings of Artaud: *Antonin Artaud: Works on Paper*.

I was responding thereby to the invitation of Margit Rowell, chief curator, Department of Drawings. She was responsible for this exhibition, and I would like to thank her once again.

This lecture attempts to draw close to the one who nicknamed himself Artaud the Mômo. Its title, *Artaud the Moma*, was making allusion in advance, of course, to the theme of the museum that is in fact at the center of my remarks (MoMA, as everyone knows, is the familiar nickname given, throughout the world and by way of abbreviation, to the Museum of Modern Art). But *Artaud the Moma* also interrogates the strange event represented, in 1996, by the exhibition of works of Artaud in one of the greatest museum institutions in New York City—and the world.

This title was not deemed presentable or decent by MoMA. My lecture, the only one given in the museum itself on this occasion, therefore bore no public title ("Jacques Derrida . . . will present a lecture about Artaud's drawings"). At my request, the

voice of Artaud (*Pour en finir avec le jugement de dieu* [*To Have Done with the Judgment of God*]) was heard at the beginning and the end.

This lecture is thus published here, for the first time, with its original title and accompanied by the necessary reproductions.[1]

It was also given, in 1997, at the Fondation Maeght, in Saint-Paul-de-Vence, France, and I want to thank Jean-Louis Prat for the generous hospitality he offered me there once again.

I am also grateful for the immense courtesy of Antoine Gallimard at Éditions Gallimard and of Serge Malausséna, Antonin Artaud's nephew, whom I had the chance to meet for the first time in New York on the occasion of this great exhibition.

ARTAUD THE MOMA

"And who / today / will say / what?" "Et qui/aujourd'hui/dira/quoi?"

What a question. You see it thrust its letters with one blow into a drawing; this question asks no determined question. With one stroke, it draws back. It awaits no word in answer from the drawing. First of all, it inscribes itself in fact, in its fashion (it is the *fashioning* or *facture* of this *faire* that interests us) in a graphic work, it participates in the putting-into-space of visible bodies, forms, and lines. One word beneath the other. Second, it is not a theoretical question but a *coup*—a blow struck or a stroke— specifically, a stroke of the pencil that took place, the day of *today* when it was struck, as one strikes a blow, on the paper, only once, one unique time.

"And who / today / will say / what?": this mimed question of a blow, at one blow, is not, however, a "rhetorical question." So then what? I am miming it in turn; I am relaunching it and then I am framing it. I am immobilizing it in a tableau. Finally, I am pretending to install it here, today, on the threshold of this

exhibition. Here it is, at MoMA, here it is once again, after the fact, *après coup*, one more time, in the imminence of what has just barely begun: "And who / today / will say / what?" "Et qui/ aujourd'hui/dira/quoi?"

I repeat these words; they precede us and not just in time. They are before us and in front of us. Today, which is to say, when? Today, in an instant, someone is going to sign, asking himself "And who / today / will say / what?"; today, October 16, 1996, is July 2, 1947. For a long time, almost a half century, these words will have set out their graphic body in a unique space. Their superimposed handwritten letters had already been planted near a skull crowned in blue, and their lines had been aligned, spread out, stacked in color, like musical notes at different heights, on the surface of a certain support. I am citing these chromatic notations as a reminder; we know that they date a certain day and that they date *from* this day on which they took place at one blow. But anyone can decipher right here their silent graphism, this mute interrogation that, in effect, says nothing at all: neither who nor what. "And who / today / will say / what?"

What is that question mark doing lost in the indecisive decision of the author, on the border between two colors? It seems to suspend what is a question in form alone, a mute sentence that attempts through color, plastically, to give us to hear that it certainly wants to say nothing yet: neither who nor what. A thing—because it is also a thing—does not know what it wants to say, neither who nor what. Perhaps, in truth, it means nothing, it wants to say nothing at all and especially not to know yet how to want to say: "And who / today / will say / what?"

Although it says nothing, this phrase-thing *acts*: thing, act and art, it *does*, it fashions something with words. In what fashion

does it do what it does? This fashion, this *facture*, is what we are going to call its *coup*, the event of a *coup*, the taking-place of its *coup*.

Who does what? Today? What is a *coup*? And what does the *facture* of this act do *with* a museum? What does it do *to* a museum of modern art? To the address of a museum of modern art?

I am not just quoting this interrogative grammar. It is as if I were already pointing out, on a hanging at MoMA, a little piece of graphic art, a half-lost inscription in the corner of a portrait in pencil and pastel, a cluster of words hung on the blue crown that covers the hair of Jany de Ruy:

"And who, / today, / will say / what?"

The question mark is inscribed July 2, 1947; the date is readable there where it seems to form the pedestal of the signature: Antonin Artaud, July 2, 1947. I will not overload its meaning and its necessity. It is not impossible that for a brief moment, on that date, before or after the drawing, Artaud searched for words. In a light and accidental fashion, with a stroke of chance, while smiling a little, he would then have decided to leave here the ironic trace of a signature forever suspended on the edge of a work whose subject and object also remain to be interpreted: "And who, / today, / will say / what?" A signature in the form of a sentence, on the edge of the work, but *in it* and along the *upper* edge, this time, as if Artaud had wanted both to extend and invert the tradition of certain medieval emblems. The latter, as you know, often bore at the bottom of the image, near the lower edge, a text, a legend, what was called a *subscription*.

Who will ever say why, today, at the intersection of necessity and chance, I had to begin by letting you hear the spectral voice of Artaud, a moment ago: a dumbfounded speech, both reproduced and alive, animal and superhuman, crying out, piercing,

cruel, older than we are, so much more archaic but also younger with the future that, manifestly, it announces?

Let us not confuse this future with the New York triumph of a glorious autumn. Ascension or assumption of a Western autumn that, quite rightly, would have stunned, worried, or outraged Artaud's friends and accomplices a few decades ago—not to speak of the revenant Antonin Artaud himself. Not to speak of him, that is, to speak otherwise than the one who often presented himself as a ghost or revenant, and not only in *Le retour d'Artaud, le Mômo* (The return of Artaud, the Mômo). To speak, in other words, of the future, of the coming and the event of the one who, in his "Interjections," greeted the "electrical discharge of the child revenant," while on the facing page he feigned to sign in these terms: "Well, it is I, Antonin Artaud, who has said all this, and it is what I want, because Satan, that's me."[1]

Let us try to think another future whose provocations still come to us, prefigured, from all the faces that look at us here. During that year, and especially around the month of July 1947, Artaud draws more and more portraits and writes several great texts on the face. *On* the face: understand by that *on the subject* of the so-called human face and even *right on* the faces he draws in color.

Who will ever say, above all, why I had to begin again with this question of the "today" ("And who, / today, / will say / what?"), there where it precipitates everything, at the point of the pencil and the chalk, which, striking a blow at the head, anticipate, capitalize, and at the same time decapitate the whole of the whole, which is to say, the *who* and the *what*? Which is to say the *who* and the *what* that puncture in advance the walls of the *which is to say*? Who will say the *which is to say* that carries beyond saying when it articulates the organs of a discourse with those of a visual art? And when it regulates grammar and syntax by the laws of

the phoneme? When it adjusts vociferation to a graphic of words and things, or even to a graphic without word and without thing?

I believed I had to decide to begin in this way for at least one reason: in view of dating right here, that is, of signing the event of the right-here and of recalling an injunction. Which injunction? If we hear him, if at least we want to listen to him, then we have to obey Artaud the Mômo; we have to obey the order, the demand, or the imprecation (an imprecation, as its name indicates, is also a prayer) that carries Artaud's last signature, which is to say, on the work, on art, and on the body of the one who called himself one day, and then forever after, until his death and beyond, Artaud the Mômo. Sometimes the article was effaced by the hyphen and the couple or the pair copulated until there was only one: *uph'en*, Artaud-Mômo. Sometimes even the hyphen disappeared.

The voice that calls and nicknames itself thus, Artaud-Mômo, enjoins us to demand the singularity of the event, namely the *coup*, the chance *coup* but also the indivisible *coup*. It enjoins us to rebel against reproductive representation, whatever the cost. To be sure, by the reproduction, again, of a doubled *coup*, a re-percussion, but against reproduction, against technical reproduction, genetic or genealogical reproduction, it enjoins us to reaffirm the singularity of the *coup*.

Our question, then, one of our questions would be, I repeat: *what is a coup?* What does the word *coup* mean in French? And what happens to a question when it is done in one blow, *d'un coup*, when it is made into a blow, when it strikes a blow? What would this have to do today with a museum? And, for example, with an exhibition in a museum such as MoMA?

So as to give oneself over to the force of this blow, one must cruelly expose, I mean exhibit, this exhibition. To reaffirm singularity is sometimes the chance afforded by a museum, the chance

of a hospitality to which one must give thanks, since a museum exhibits original works and in principle banishes reproduction. Gratitude to MoMA does not prohibit us, however, from posing a question here, but a question always *lightning-struck*, that is, *foudroyée*, by Artaud-Mômo: it is the serious and inexhaustible question of the Museum. Here, today.

I say *foudroyé, lightning-struck* so as to salute what I see as the very figure of a phenomenal apparition, the event named Antonin Artaud, his meteoric existence, his passage in a flash across literature, poetry, theater, and the arts you call visual, his apparition as luminous, dangerous, mortal, exceptional lightning, as well as his thunderbolt, his *coup de tonnerre*, in our history's skies, in a history of art whose concept he will have sought to attack and virtually destroy (and one may say this even if, like me, one does not always like or approve of the philosophical or political content, the ideological themes at which, in spite of everything, this lightning-man stops, against which he strikes without always raising them, transfixing them, or submitting them to powerful enough X-rays; in particular I resist everything in this work that, in the name of the proper body or the body without organs, in the name of a reappropriation of self, is consonant with an ecologico-naturalist protest, with the contestation of biotechnology, reproductions, clones, prostheses, parasites, succubim, supports, specters, and artificial inseminations—in short, everything that is im-proper and that Artaud-Mômo, as you heard, identifies very rapidly with America, in 1947, in *Pour en finir avec le jugement de dieu* (*To Have Done with the Judgment of God*). I must admit, too quickly of course, that unlike almost all those with whom I share a passionate admiration for Artaud, I am also bound to him by a sort of reasoned detestation, by the resistant but essential antipathy that is aroused in me by the declared content, the body of doctrine—assuming one can ever dissociate it from the rest—of

what might be called, thanks to a certain misunderstanding, the philosophy, politics, or ideology of Artaud. This would deserve a long explanation; you could follow its just visible thread through what I am going to say today, as I have been saying already for thirty years. I thought it incumbent on me, however, to situate here, if only in a few words, *the* front, a sort of incessant war that, like antipathy itself, makes Artaud for me into a sort of privileged enemy, a painful enemy that I carry and prefer within myself, at closest proximity to all the limits against which I am thrown by the work of my life and of death. This antipathy resists, but it remains an alliance; it commands a vigilance of thinking, and I dare to hope that Artaud, the specter of Artaud, would not have disavowed it. And before accusing Antonin Artaud of this metaphysical rage for reappropriation, I believe one must lay blame on a machination, on the social, medical, psychiatric, judicial, ideological machine, on the machine of the police, which is to say, on a philosophico-political network that allied itself with more obscure forces so as to reduce this living lightning to a body that was bruised, tortured, rent, drugged, and above all electrocuted by a nameless suffering, an unnameable passion to which no other resource remained than to rename and reinvent language. Which was done and signed Artaud, Artaud the Mômo, during the last ten years of his life, no doubt the most terrible years, the most wounded and the most creative. This glossolalic or glossopoetic rebirth of language is never separated, in his project, from the graphic lightning that burns all the drawings and portraits that surround us. One need not subscribe to Artaud's theses, to his implicit or explicit philosophy, to his ideological propositions to recognize the torture endured, the *suppliciation*, as he would have said, the electricity of the electroshocks that he underwent literally and figuratively. This whole electrocution irradiated him. Like a lightning bolt, like a bomb of light, it lit up this witness;

it made a torch of this seer—I dare not say this martyr for fear of re-Christianizing his insurrection against the Christianity that devoured and parasited his body. He burned and pierced holes in the very limits and metaphysical figure of his discourse, just as he did with the paper of the *Sorts* (Spells) that we will talk about later. I find that in those who, from within the metaphysical enclosure, let themselves be electrocuted, all the same, at the crossing of the hyperbolic limit, there is always more of interest and more passion than in so many others who believe they are criticizing or deconstructing from some comfortable and presumed outside. And for him, for us if we know how to see and hear him, the fiery blows, the flashes of this lightning lit up everything with an incomparable lucidity, to the point of inflaming the edges and the center, the system of limits and the expropriating machine whose victim he was. This system and this machine (*La machine de l'être* [The machine of being], to mention the title of a work exhibited here whose literality I have tried to analyze elsewhere, trait by trait, word for word, or syllable by syllable), articulate together in a same body, in a same spectral figure, the Christian West, the god who steals my body, the spirit, the holy spirit and the holy family, all the forces—ideological, political, economic— that are one with this thief of bodies, with the literature, theater, and art that descend from them, with the archive and the hierarchy, the sacralizing and poisoned hierarchive of this accumulated culture, between Europe and the American colonization. The museographic institution, as we will hear, would be one of the great bewitched incarnations of this evil, something like the Western pyramid of this hierarchive.

Artaud himself named this lightning passage, this flash of electricity in his drawing, and he did so precisely through the insulting imprecations he casts, like so many deliberate blasphemies, against

god, against the god of the holy family. In the sort of *vade mecum* that accompanies the drawing titled *La maladresse sexuelle de dieu* (The sexual maladroitness of god), he explains his own apparent and feigned maladroitness. This *vade mecum*, which is also a *vade retro Satanas*, recalls the electricity of lightning. It pretends to propose to electroshock god in turn by the very act of the drawing, more precisely by causing to pass through him a new electricity that will recharge the worn-out batteries of the Trinity:

> The tomb of everything waiting while god fools around with the instruments at the level of his belly that he hasn't known how to use.
> Themselves maladroitly drawn so that the eye looking at them falls.
> **yo kutemar tonu tardiktra**
> **yo kute drikta anu tedri**
>
> It is my work that has made you electric, say I to god, when you always took yourself to be a battery that will not be worth the battery with which I am going to do you
> knicky knack [*dont je vais te/coli fi ficher*]
> with which I am going to knick knack you
> you rascally old antero-colitic . . .

(*OC* 20:170 FF.)

Later, in the same *vade-mecum-retro-Satanas*, an analysis of which could show that each of its syllables in French is just as untranslatable as the glossopoiesis that seems to interrupt them, the drawing electrocutes once again the holy family, after another

glossopoetic interjection. Two more blows, two rifles / *fusils*, two rifle shots / *coups de fusil*—and two charcoal strokes, *deux coups de fusain*—explode there, they cause history to explode, the brilliant luster of "the illustrious history of belief in god." One must realize that the blow struck is always the percussion of an electrocution. To strike a blow, *le coup férir*, is not only to electroshock but also to light up with fire, to take into view and to make visible the electroshock, to draw its picture as if on an operating table or a torture table:

> For it is thus that with the four irons of the table of the sex of
> the open incest the soul who wanted to lie with its father,
> to sleep astride the way one horses around the virgin phallus,
> rifle root of the <u>electric</u> night,
> rifle to pierce through the illustory misery, the illustrious history
> of belief in god,
> when I'm the one who does it,
> pronounces the soul,
> when I ejaculate this yellow-bellied fart.
>
> And I say that my soul is me and that if it pleases me to do
> a girl who one day wants to lie down on me
> do caca and peepee on me,
> I will do her in the face of and against god the spirit of shitty retention who is always farting on me, spurting out like a bomb with his paradise on the walls of my cranial niche, where he has incrusted his nest.

(OC 20:172)

Fart against fart, a double rifle *coup*, the electrocuting pencil *coup* is not merely going to recharge the divine battery. It explodes

the bomb that god, the parasite, has deposited in his skull like an animal that has taken up residence there, where this animal-god installs its offspring, like a dog that finds its niche there or a bird that lays eggs in its nest.

About this drawing, Artaud says that it is

> deliberately botched, thrown on the page like some scorn for the forms and the lines, so as to scorn the idea taken up and manage to make it fall.
>
> The maladroit idea of god deliberately made not to stand up straight on the page . . .

One would have to analyze the whole quasi description, the active and playful interpretation of this sexual maladroitness of god. From one end to the other, it commands a jubilant admiration, notably as concerns the play of the *tombe* and the *bombe* of the divine maladroitness and of a detumescence that is both graphic and sexual. The meaning joins up with the sonorous form of the words *tombe, tomber, tombeau* (grave, falling, tomb) so as to play with the graphic forms of the drawing. The text attacks with the word *tombeau* and the first phrase ends—or falls—in its last word on the word *tombe* as verb ("l'oeil qui les regarde tombe," "the eye looking at them falls") and not as noun (*la tombe* [grave or tomb]):

> The tomb of everything waiting while God fools around with the instruments at the level of his belly that he hasn't known how to use. Themselves maladroitly drawn so that the eye looking at them falls [*tombe*].

A little further on, everything gets reversed. The phrase moves from the *tombe* to the *tombeau*, more precisely from the

singular noun *tombe* ("la tombe de mes fesses," "the tomb of my buttocks") to its division or multiplication into *double tombeau* (double tomb). The trajectory, therefore, sets out from my own body, at once the belly of a pregnant and necrophoric mother from whom emanates in a fall, as in the dropping of childbirth, the handicapped spirit of this retarded god; then from the pregnant tomb of my body the line goes to the coffin *in which* I am, or even to the coffin *that* I still am, "la boîte de l'ange dans mon double tombeau craquant," "the angel's box in my double cracking tomb." One always reads in this text, and quite rightly of course, the active commentary, or even the credits, of *La maladresse sexuelle de dieu* (February 1946). I wonder if it does not also refer to, and by the same token agree with, the picture from the following month (March 1946) titled *Le théâtre de la cruauté* (The theater of cruelty). Metonymy of Artaud's entire work, this *theater of cruelty* also exhibits the mortuary box, in a more identifiable fashion, as a doubled coffin, twice doubled around the double mummy that is thereby commemorated, commummified, commomofied, commomotumefied by the blows. In the margins of another picture, *La Mort et l'homme* (Death and man, April 1946), the concerted configuration of the verb *tomber*, conjugated in four grammatical forms (*tombait, tombant, tombé, tomber* [fell, falling, fallen, to fall]), verges on the tomblike "boxes" or "coffins" (with or without padded lining), repeated *coups* and *souffles* (breaths) that breathe as much as they steal the breath away. It is a matter then, as always, of producing a physical effect on the very body of the spectator and of leaving a trace there of a quasi-organic transformation, depriving him precisely, and violently, of his objectifying position as spectator, as contemplative voyeur, by affecting his very eye. It is a matter of changing the eye with the drawing, of inventing or adding a new eye

or, through the violence of a paradoxical prosthesis, of restoring a lost eye. Through this surgical operation, though the ophthalmological traumatism produced there by a sort of virtual fire or laser (and Artaud names, at this point, virtuality), the drawing would thus proceed to detach the retina. But this detachment would permit the installation of the thing itself, the represented thing, the skeleton of death, in the eye itself, without support. Separated from the page, lifted from a subjectile that figures that from which the retina is thus detached, the body of the thing itself, death or its skeletal representation, would then come to plant itself in the gaze. More precisely, thanks to the detachment of the retina, it would come to find its "place," there where it finally would take place, namely, "in my eye." What will be important for me from now on, in these traits and these blows, is also the attack on the support, this way of putting an end to the stable support, and therefore to art and the Museum, to the static state of the work of art and to the state period, but also to all that can be figured by the support, beginning with the matrix or the patrix, the father-mother, the pair of the father-mother. Speaking of his drawing *La Mort et l'homme* insofar as it "remains then not in space but in time," Artaud in fact dreams ("I would like," he says) a sort of virtual prosthesis of the gaze. He dreams of putting in place a new eye, the first or the last, in another place. He would like the event of another taking-place in the eye:

> I would like that while looking at it more closely one finds there that
> sort of detachment of the retina, that as it were virtual sensation of a detachment of the retina that I had while detaching the skeleton from the top, of the page, as a putting-in-place for *an* eye.

The skeleton from the top without the page with its putting-in-place *in* my eye.

(*oc* 21:232–33)

Death, eye, phallus, blow. The discourse *on* the sexual maladroitness of god is addressed first of all *to* god, to an imitated god incorporated in oneself (and the evil, the grievance concerns the dramatic history of this forced incorporation). Each drawing, as we will see, is a blow, strikes a blow, and this blow *falls* (*tombe*) on someone only to the extent that, far from being a representative *reference*—either figurative or abstract—it apostrophizes someone, it attacks an addressee, only to the extent that it knows how to strike a blow (*un coup férir*) against this one and not that one and knows how to fall on him or her on such and such a day in such and such a place. Now, any spectator of the drawing can become the addressee, that is, the target of this blow. The addressee is the one who receives the blow. An inevitable result to the extent that, receiving, seeing, reading, he feels hit by the message or the missile, the insult or the assault of the apostrophe:

> While you are farting in your clouds, you species of spiritual incompetent, issued from the tomb of my buttocks,
> **yak ta kankar ege**
> **narina**
> **ege narina**
> **anarina**
> I turn over the angel's box in my double cracking tomb.

(*oc* 20:170–71)

The polyphony of the near homonyms of *tombe* and *tombeau*, which scan the narrative of the "sexual maladroitness of god," "the illustrious history of belief in god," can be heard rebounding from *bombe* to *pudibonderie* (prudishness) by means of the soul *qui se débonde* (that unstoppers itself), up until the maladroit drawing causes once again the idea to "fall" (*tomber*). Across this polyphonic narrative of alliterations (*bombe, tomber, pudibond, débonder*—the latter is very close to *débander*, that is, to give in to detumescence: the fall of the phallus or the pencil in sexual and graphic maladroitness), one deciphers also a genealogy of god, spirit, religion, namely, of all that is engendered in the repression of "retention" (*retenue*), of modesty and prudishness. How is one to read this retention or restraint, this *retenue*? The word is Artaud's and he repeats it within several lines, aligning it both with modest reserve and with the intestinal retention of excrement; elsewhere, in a seemingly very different context, I have tried to show that the experience of retention, restraint, modesty, or respect is the experience of religiosity, sacralization, or sanctification itself.[2] *Retenue* is at once the origin and the manifestation of spirit (of the inside), of god, of the holiness of the holy virgin (*vierge*) or holy candle (*cierge*); it is also that which, in intestinal retention, produces the wind of spirit, the fart that Artaud also calls "the internal gas of spirit" (and let us not forget that gas is also *Geist*, an etymological and semantic affinity I have analyzed elsewhere, in the vicinity of Hegel and, that time, of Genet; *Geist*, spirit, is also *ghost*, the specter that comes to haunt or parasite the body proper, the stranger that must be chased outside). This holy spirit, this restraint, this farting retention is what Artaud no doubt wants to deliver himself from, but first of all he wants, through the *coup* of this drawing, to assign it to others and recall that it is not his: it has been imposed on him, like a tax or a hound

from hell, by a law of the holy family that first of all stole his own body proper. It's a matter here of a malevolent and universal conjuration, that of a spirit sufficiently diabolical and perverse to worm its way into its own victims and make them accomplices in their own illness. We should analyze all the elements of this drawing, all the chalk strokes in blue, green, rose, ocher, and black that *describe*, but one should say rather *weave*, *plot*, or *provoke* this universal catastrophe: at the same time the vertical movement of the fall, the detumescence of the phallus when it lets fall the spectral sperm of its spirit, and the inward agitation or even fermentation of the viscera that produces the internal fart or gas of spirit, at the center of the feminine belly, at the heart of the breasts (*au sein des seins*), which perhaps let fall their holy family milk all along a divine milky way. It is also a bible of interiorized nourishment and of excremential dejection, a treatise on the alchemy that transfigures the substance of shit into incorporeal spirit. This clinical catalog of psychopathology derives all man's illnesses from a sexual maladroitness of god who, through usurpation and imposition, has become, within himself, his own awkwardness, the maladroitness of man lacking in spirit. The same drawing, in the same blow, would have to denounce it, correct it, redress it, but also expulse it by exorcising it. One should look while listening to or reading at least the passage that immediately follows the one I lifted out a moment ago and that, as too often, I must once again violate by cutting. The text and the drawing engender each other; one cannot say which one erects or precipitates the other in its fall. I can do no more than underscore a few words:

> *rifle* root of the *electric* night
> *rifle* to pierce through the illustory misery, the illustrious history
> of belief in god,
> when I'm the one who *does it*,

pronounces the soul,
when I ejaculate this yellow-bellied *fart*.

And I say that my soul is me and that if it pleases me to do a girl who one day wants to lie down on me
 do caca and peepee on me,
 I will do her in the face of and against god the spirit of shitty retention who is always farting on me, spurting out like a bomb with his
paradise on the walls of my cranial niche, where he has incrusted his
nest.

The soul must *pull the stopper* on all the holy substances species that nourish this ancient orgy of the spirit against my man's carcass on the soil of illness.

For I, man, have suffered from the spirit:
without a soul on this bed couch of my body that can finally after life believe itself a child on a bed.

Will this soul have eternal rest, against the *internal gas of the spirit of jealousy* [gaz interne de l'esprit de la jalousie] from which men have *eructated* [éructé] god.

For the *restraint* [retenue] of prudishness [pudibonderie] is not mine but that of all those *who are immodest in spirit and who imposed the holy virgin* [impudiques d'esprit qui imposèrent la sainte vierge] on things so as to satisfy themselves on the sly, protected from this candle idea that lays waste the sex of man in order to supply the nothingness of *spirit* [here Artaud underlines the word *esprit* in this unheard-of proposition or exposition: to lay waste the sex of man in order to supply the nothingness of spirit; *spirit* would thus be a dressing, an ornament, a supplement of nothingness, but a supplement of non-being as charge, tax, imposition of the tax by the hellhound—*munus*—and munition that comes to corrupt originary

immunity; spirit is the being that corrupts originary immunity thereby defined as non-being; but this non-being is in truth the essence of spirit, which is but its armed supplement, the rifle or the *munition* with which it *arms* itself (munition *dont il se munit*)].

This drawing is deliberately botched, thrown on the page like some scorn for the forms and the lines, so as to scorn the idea taken up and manage to make it *fall* (tomber).

The *maladroit* [maladroite] idea of god *deliberately made not to stand up straight* [volontairement mal dressée] on the page but with a distribution and a blaze of *consonant* [consonants] colors and forms that *make* [fassent] this *ill-fashioned thing* [malfaçon] live . . .

Upon listening closely to this last sentence, upon rereading yet again every word, one has to ask oneself: when, in that case, is there a work, and a work of art? When and where? Where is one to situate, virtually, for this act of voluntary maladroitness, for this *malfaçon* or this *mauvais coup*, this botched stroke and low blow, a place of reception and assembly, a subjectile, a church or museum wall? What happens at the instant the *evil is done* (le mal est fait), the satanic evil ("I am Satan," he said)? What remains at the instant the evil is *done well* (*le mal est* bien fait), the *mal* also of *maladresse* (maladroitness or awkwardness), and of *malfaçon*, the *mal* of the "scorn for the forms and the lines," the *mal* of the destruction of art and its place, or even of its archive, its cumulative conservation, its reproduction, and its exhibition? Its virtualization and the museographic management of its surplus value? Its canonizing idealization or its academic sublimation? At the instant the evil is done, done well, it sublates its chaos, it keeps itself even in discord, it keeps the trace of the blow struck in a counterblow or a doubled blow, it thus saves its dissonance in some "consonance." This is done, I was saying, and the evil is done, "at the instant that," and this takes

place in fact in an instant, a blow, an act. But this instant must be divided or doubled in order to keep the trace of its own blow. And in this duplicity of the blow destruction is kept, but it is also kept from pure and simple destruction, evil against evil, evil in evil: the work, the work of art has already found the support and the place of virtual reception, already a museum, to safeguard the memory of their autodestruction. This salvation also means loss, and this contradiction of the doubled blow is no doubt the cruelest fate of the cruelty out of which Artaud will have made his theater. Art is saved or redeemed perhaps from the fall by what, in Artaud's words, "makes" "live" the *malfaçon* itself, namely, the art of a "distribution and a blaze of consonant colors and forms that *make this ill-fashioned thing live.*" It is thus a matter of causing to live, and live on the *mal fait*, that which is badly done and that which does evil or harm, the very thing that signs the end of art, namely, spirit. It has to go very quickly. The speed of a precipitation is an essential trait of the operation. The line must follow the precipitous rhythm of the sketch. But this absolute speed cannot erase the minimal insistence of the trait divided in its act by the very doubling of the blow. By its repercussion and by its echoing. A *precipitous* blow, which is to say in good Latin-French, head first. The drawing keeps the visible testimony of this precipitation, of this "fashion" that saves the "ill-fashioned" by keeping it, exactly like a survivor, and a capital witness of the precipitation. Aim is taken at god's head and sex. Artaud describes precisely this witnessing. After having noted the "distribution" and the "blaze of consonant colors and forms" that "make this ill-fashioned thing live," causing it thus to *live on*, he insists twice on haste, the "hasty sketch" and the "hasty fashion":

> witness the head at the top like an egg barely indicated and the beards rays of hair that could have been but a hasty sketch

in a more elaborate drawing but I wanted their *hasty fashion to remain* at the summit of this red puppet,

 like a spot that is going to spread out over the clothes and weigh down on the piss-sex.

(OC 20:173)

One must do what is necessary, then, for the chance of a survival; there must be a remaining (*restance*), a reverberating remaining of the very thing that does not remain, namely, haste, the disastrous collapse of impatience that botches everything; it must "remain," there must be a witness to the haste and to the *malfaçon;* the "hasty fashion" must "remain"; one must make it live and live on as witness to the divine collapse after the blow is struck, and the color must run from the egg-head like a yolk that blushes red in shame, like sperm become piss (thought when it falls into representation, said Hegel).

Lightning-struck, *foudroyé*: another reason I say *foudroyé* is to describe the traces of a passage, the time, rhythm, and landscape of a sleepless white night, the earth and sky of the works assembled in this museum. *Foudre*, lightning, is a word that Artaud himself chose, on more than one occasion, and lightning, so as to speak of what happened when one day began for him a certain experience of the drawing. Not of drawing in general (he had been drawing and painting since adolescence with a technical mastery that is so much in evidence here), but of *this* drawing that *one day*, beginning in 1939, he could no longer dissociate from writing. He then names lightning twice. In the word *foudre*, one hears the explosion of a missile, the deflagration of the breath or the conflagration of an incendiary bomb. But one also hears, at a greater or lesser distance, other words that Artaud regularly associates with it: close to *foudre* there is *foutre*, copulation and sperm, which

multiplies the affinities with the word *poudre*, powder (one of Artaud's favorite words for designating gunpowder, as well as seminal dust, greasepaint or face powder, paint pigment—or that which is reduced to ashes in destruction by fire), and especially with the monosyllable *fou* (mad) and thus with the word *mômo*, which means, among other things, something like crackpot. *Foudre* is not far from *foutre*; it inflames the living sperm, and this mad torch is nothing other than the body, the body proper itself: "for what is the spirit without the body?" asks Artaud in *Suppôts et suppliciations* (Henchmen and torturings; *OC* 14:63). Answer: "A limp rag of dead *foutre*." If the spirit without the body is dead (or artificial) seminal fluid, as for the body, it is vital sperm, burning come, hot cannon barrel. And the force of the drawing would be to ex-pose it.

At the opening of the famous text from April 1947, "Dix ans que le langage est parti . . ." (Ten years since language left . . .), Artaud lets loose the lightning bolt:

> Ten years since language left,
> since in its place came in
> this atmospheric thunder,
> this lightning,
> in face of the aristocratic pressuration of beings
> of all noble beings
> of the ass,
> cunt, of the dick . . .

"Ten years since language left": what a declaration! It announces that language left me, for it has gone and left me without it, abandoned, but also, more secretly, that it left or departed *from* me, that it took its departure *from* me, by me, proceeding thus from me by the lightning of my drawing. For further down,

like a meteoric body detached from it by the lightning itself, the word *fou* is associated with *mômo: mômo*, remember, means mad, *fou*. The lightning of the mad man (*la foudre du fou*) passes by way of the drawing's body, more precisely by the body of a "black pencil." And, as you will hear, the "black pencil," the drawing body of the drawing, the ligneous and rigid verticality that strikes the blows, the "pencil blows," is a lead as black, black like evil, but also sometimes as colorful in its wooden coffin as the paper scorched by flame: I mean the *Sorts* (Spells) that are waiting for us.

At Rodez, Artaud most often used, as we know, a black graphite pencil, but also sometimes those waxy, colored crayons that children play with. He found the supports for his drawings, that is, also the targets for his pencil blows, in stationery or typing paper.

The mômo presents himself, therefore, he presents his truth, the fiery truth of a thunderbolt that follows the flash of lightning, and this blow strikes in the night like the blow from a madman's black pencil:

> Ten years since language left . . .
> How?
> By a blow . . .
> anti*dialectical*
> of the tongue
> by my black pencil pressing
> and that's all.
> Which means that I, the madman and the mômo,
> maintained 9 years in an insane asylum for passes of
> exorcism and
> magic and because supposedly I imagined that I had found a
> magic and
> that was mad,
> one must believe that it was true . . .[3]

Such an "it was true" does not mean "it was real." No more than in the untitled drawing from January 1945 that bears at its head, at the top of itself, the header that then becomes its title: *Jamais réel et toujours vrai* . . . (Never real and always true). "Always true," then, of a truth without realism, and without naturalism, and without figuration. One could analyze infinitely the symbols projected and the spells cast in this drawing. I note merely that the capital height of its sentence without verb ("Never real and always true") receives from below the light of an interpretation, at the foot of the drawing, in the form of an incrimination of art, or even, more precisely, of the signifier "art," of this morsel of the name *Art*aud, art *qui se fait mal*, art that is badly done, that does itself harm, that undoes itself and reverses itself into the maladroitness of a *ra-tée*, a misfire, a botched job, the *malfaçon* of a ratatouille, of a *rate* (spleen), or of one of those rats, of those *ra* syllables that runs in crowds and teems throughout Artaud's corpus. On the lower edge of the drawing, one follows in fact what could well be the explicating consequence of the "Never real and always true," namely: "Not art but some *ra-tée* of the Sudan and Dahomey."

"Lightning" comes back again later in "Ten years since language left . . ." Lightning strikes the drawing. It then carries off with a single blow (*coup*) struck what is called a "pencil stroke," that is, *un coup de crayon*, on the paper, a common figure whose physical and literal energy Artaud always knows how to revive. In the passage cited earlier, one blow after another, Artaud was already calling for a "blow . . . of the tongue" ("By a blow . . . antidialectical / of the tongue / by my black pencil pressing"). Here comes another blow, no doubt the same blow, but this time divided or multiplied, doubled, repercussed, in the plural: pencil blows, "my pencil blows." One cannot understand, I believe, the operation of Artaud's graphic cruelty without a thinking experience of the double blow, without this trace of *repercussion* that I will try to formalize a little

later. The repercussion of electrocution constructs and destroys at the same time the history of art in its museographic truth. In any case, the drawing inaugurates by inscribing the charter of a new Kabbalah that "will today say what" while projecting its excremental projectiles onto the old Kabbalah, that of tradition, which is to say, as the very name *Kabbalah* indicates, onto the very Tradition of yesterday. And Kabbalah or cabal also connotes, in ordinary language, conjuration, plot, conspiracy. What is embarked on in the drawing is the war of one conjuration against another, the assault of one spirit, thus of one breath, against another, a pneumatic *polemos*, one respiration against another, the conflagration between two inspirations and two conspiracies. And this is the end of Art, of the history of Art, with a capital *A*, of Art for Art's sake, the Art whose cult we pretend to celebrate or end up celebrating in museums, even if that is not what they were meant for from the first blow. I have underscored some words:

> and I say then that with language set aside it's *lightning* [foudre] that I caused now to come into the human fact of *breathing* [respirer], which lightning is sanctioned by my *pencil strokes* [coups de crayon] on the paper.
> And ever since a certain day in October 1939 I have never written without also drawing.
> But what I am drawing
> are no longer the themes of *Art* transposed from the imagination onto the paper, they are no longer affective figures,
> they are gestures, a verb, a grammar, an arithmetic, a whole *Kabbalah*
> and that *shits* at the other, that shits on the other,
> no drawing made on paper is a drawing, the reintegration of a misguided sensibility,
> it is a machine that has *breath* [souffle].

At the end of this famous text from April 1947, which removes drawing from Art, from the "themes of art" and, at least four times, makes of graphic lightning an emanation from vociferating breath ("a breath that gave its fullest," "it's been ten years that with my breath / I breathe hard forms," "all breaths in the hollow arcature," "Not one that is not a breath thrown with all the force of my lungs, / with all the sifting / of my respiration"), the end of Art is but the same thing as the end of writing for writing, of the letter for the letter. This is the last word of the text: "And this means that it is time for a writer to close up shop, and to leave the written letter for the letter." To leave the written letter for the letter: this can mean two things, precisely here where Artaud says "And this means." It can mean, in the first place, the end of the written letter for the letter (as one says the end of art for art's sake, of literature for the sake of literature). It can also mean the end of the written letter *so as to* make room for the true letter, *with a view* to this letter finally, which would no longer be written but in a single shot breathed-drawn, respirated-traced, and this is the drawing, the *character* of Artaud the Mômo. The latter, already at Rodez, claimed to have a drawing know-how that, through an apparent maladroitness, made plain the abandonment of the "principle of drawing," the end of the school and of art so as to retake possession of his body against the obscure forces of the spirits that were trying to dispossess him. Speaking no doubt about a drawing in which he represented himself as king of the Incas, as he does here, Artaud made a claim for the soul against the spirit, the living soul as a sort of physical or nervous work of the body and of the *hand*, of the *manner* and the maneuver (*main d'œuvre*, labor) by means of a sort of fictive *tabula rasa* of the history of art, "as if he had learned nothing." He was describing, by the same token, at the same blow, all his "other drawings":

> This drawing like all my other drawings is not that of a man *who does not know how to draw, but that of a man who has abandoned the principle of drawing* and who wants to draw at his age, my age, *as if he had learned nothing by principle, by law, or by art*, but only by the experience of work, and I should say not *instantaneous but instant* [non instantanée mais instante], I mean immediately deserved. Deserved in relation to all the forces in time that are opposed to the manual work, and not only manual but nervous and physical, of creation.
>
> Which is to say against the taking possession of the soul into spirit, and its putting-back-into-place in the being of reality.
>
> (OC 20:340; Artaud underlines "deserved")

Another reason dictated my choice to begin with the colorful drawing of this question without prior content and addressee: "And who / today / will say / what?" If I have learned how to look even a little at the portrait that bears this address without address, it is thanks to the eyes and the knowledge of my friend Paule Thévenin, to whom with your permission I dedicate this lecture so as to honor her memory. We are many who, without her, cannot conceive the return of Artaud, "The return of Artaud, the Mômo" today, at MoMA, and the living-on of what must be called the "corpus" of Saint Antonin. On the word *mômo* in particular, Paule Thévenin has written some pages that we will forever need to reread because they give us (and moreover this is their title) to *hear / see / read*.[4]

Among the hypotheses concerning the choice of the nickname *Mômo* during the period when Artaud began to be unable any longer to write "without also drawing" (1939–1947), I will privilege here two threads. What I would like to make clear concerning them, because Paule Thévenin does not say this, is that these two threads are crossing here, today, in New York, even as they appear

to be both contradictory and complementary. What is even more striking is that between them they cross the two origins of Antonin Artaud. These two *topoi*, these two figures of the Mômo are also two birthplaces of Artaud. The return of Artaud Mômo would figure at the same time their repetition and a third birth, another rebirth or renaissance. You will have noticed to what degree birth, the rebirth of a brand-new corpus, of a body without organs, is the great concern of all the drawings and portraits exhibited here, from *La maladresse sexuelle de dieu* to *L'exécration du Père-Mère* (The execration of the Father-Mother), from *L'être et ses fœtus* (Being and its foetuses) to *L'immaculée conception* (The immaculate conception), from *La projection du véritable corps* (The projection of the true body) to the numerous self-portraits, which one could interpret as processes of autoengendering. Each self-portrait is a regeneration of oneself. Recall the motif of *Ci-Gît* (Here lies):

Me, Antonin Artaud,
I am my son, my father, my mother, and me;
leveler of the imbecilic periplus where engendering gets entangled,
the papa-mama periplus
 and the child;
soot from the grandma's ass,
much more than from the father-mother.[5]

From one end to the other of Artaud's corpus, an immense and turbulent and blaspheming poetics of generation repudiates, along with the Christian body and its holy family, the whole history of art that installs this body of the parasited lunatic in churches and then transfers them from the churches to the museums, in the private or state capitals of art's capital. Now, one of the possible filiations of Mômo leads us toward Marseille, where Artaud was born one hundred years ago, alongside the Provençal, Spanish, or Catalan languages. There, and "especially in

Marseille,"[6] a swarm of meanings of *Mômo* buzzes around childhood, ingenuousness, naïveté. Mômo is the *môme*, the kid, the child, the *mioche* or brat. And thus the couple or pair mother-child (Mam, mama, mum, mommy, *môme, mômo*). One can also recognize here the figure of the fool or madman (*mômo*) as village idiot, the innocent, the nutcase, in that semantic zone where the poet Frédéric Mistral derives *momo* from the Catalan *moma* (a word I wanted to greet in passing here), which has the sense of currency or money, not far from *la momo*, commodity as delicacy, candy. Among the Latin languages, Catalan, as you know, remains one of the closest to French. Thus, the *moma* is money, currency, just as *la momo* would be the child's treat to be bought and consumed. And *mômo*, the word *mômo*, retains in advance the memory of *moma*; poetically, literally, it mothers and commemorates and mummifies—with a watchful eye on several letters that we will hear ring out in a moment in the very design of the drawing—what *moma* can, at the risk of cadaverizing it, preserve in itself, in the maternal matrix, in the very matter of a mortifying gestation. I will not extend these remarks on the relations of semantic association or engendering that may affiliate foolishness with financial capital, and credulity with credit, thus with the market. In an inseparable way, inscribed on the reverse side of the same piece, stamped in the angle of the same *coin*, the other semantic phylum returns from Marseille (which was a Greek city) to Smyrna, to the Cyclades, to Greece, to that neo-Greek polyglottism that Artaud also spoke in his childhood in the midst of a family that still kept the Greco-Turkish memory of its origins. Greek is very active in his language, in his glossopoiesis and in his drawings (for example, *ana*, in the upper left corner of *L'exécration du Père-Mère* [April 1946]). It often comes back elsewhere, notably in what I called the *vademecumvaderetrosatanas* of *La maladresse sexuelle de dieu*, where the glossopoetic *Ani* links its necessity to the quasi normality of other words,

such as "Ani, in Greek aniksa . . . that old anankē, of the soul" (*OC* 20:171). In Greek, Μψμος is the god of mockery; he illustrates terrifying sarcasm with a grimace that we also find in the *mômo* buffoon. He is a "spirit (*pneuma*) full of forces," says Hermes of him. A hundred years ago, this pagan god still made his appearance in the festivals of southern France. Well, in order to read and understand something there, in order to approach the stamp of what remains living and decisive and incisive and mordant and, in a word, cruel in the portraits and drawings from Artaud's last ten years, which is to say contemporary, in sum, with Artaud the Mômo, one would now have to cross these two familial and semantic genealogies, these two geographies of the place, that is, of the body of Artaud: *on the one hand*, the return of Mômo the child, the innocent, the helpless fool-madman who comes back to put on trial the machine that detains and destroys him, body and soul; and this institutional machine is a culture that is at once social, medical, psychiatric, religious, political, metaphysical, a police-machine and a state-machine—as well as an artistic machine (the museum is one of its powers of foundation, conservation, legitimation, canonization, assimilation, a power both public and private, the capital city at the head of its capital, the market of a state speculation); but at the same time, *on the other hand*, indissociably, the indictment of the innocent child who bears the grievance of this wounded, assassinated, mortified, mummified Mômo also strikes the blows; it is the unleashing of a satanic mockery, that of the god Mômos, of his blasphemies, insults, assaults, accusations, and merciless sarcasms, of his incriminations and recriminations. Given and returned, all these blows can be felt; they still strike in each pencil stroke. A burst of painful laughter cuts across the unarmed passion of he who has just been born. A child seeks rebirth after twenty centuries and not just one hundred years of history; he is learning again and teaches us again a language before language, where

and when language left, left from me, vociferating in one-shot syllables that had never yet been pronounced. Thus a child glossopoet becomes the inseparable accomplice of a god of irony who laughs in your face and defies all cultural institutions, and the history of art, and the discipline of drawing, and the criteria of proper evaluation, good manners, and the market of art's criticism, its salons, galleries, foundations, and museums. The indictment has no limit:

> Modern historical life is the price of a tremendous and foul bewitchment.... Act of accusation against this world,
> bring to the fore the bewitchments.
> Who I am?
> I am Antonin Artaud,
> but I have always suffered from men,
> more exactly from society.

(OC 26:69)

"And who / today / will say / what?" I have just learned something else about this singular work by following a path opened by Paule Thévenin in a note to the book that I had the honor and the good fortune of publishing with her. Written not long before the death of Artaud, certain words in this *Portrait de Jany de Ruy* (July 2, 1947), were erased one day by Jacques Prevel while he was noting them down, also on July 2, 1947. I know neither why nor how it happened that, even as he was noting down the verbal message, transcribing it separately to set it aside, Prevel destroyed on the drawing what he was thus archiving elsewhere, in his own diary.[7] Did he indulge in this hijacking, this *acte manqué*, this failed but also successful act, accidentally or intentionally? Was he inspired to do it by some unconscious lucidity? In any case, the words that were thus attacked have since been reconstituted,

which is to say, *re-produced*, produced once again with the help of Antonin Artaud, Paule Thévenin, and Jany Seiden de Ruy.[8] The words were thus, through this reproduction, returned to themselves, in effect, also prepared for the catalog of an art gallery, the margins of a collection or a museum, but not for a museum itself. They were thus rescued from their loss but in their loss itself, saved in some way by the author, by a spiritual heir, Paule Thévenin, and by the model of a portrait that remains, all the same, mutilated. Restored separately, exiled outside the work, these words in fact are no longer right on the body of the drawing of which they are a part. The words are saved, like morsels of the body of the work, but the work itself is not restored. The body or the cadaver of the words are gathered up, to be sure, but their remains no longer form one body with the body of which they were once a part. One wonders what a museum keeps or exhibits when it holds only the scars of an effacement, the traces of a destruction or dismemberment, already a ruin, a cemetery haunted thereafter by decomposed cadavers.

Now, as for the erased words of this drawing, which are henceforth unreadable, invisible, and inaudible, I would be tempted to conclude that they are not insignificant in themselves or in their secret affinity. The first of these words are "I am" (*je suis*), the last "Shit on me" (*Chiez sur moi*). Between this "I am" and "Shit on me," Jacques Prevel had also erased a "je fais," I do or I make, not *je fais mal*, I do badly, *je fais le mal*, I do evil, the *mal* of the *malfaçon* or the *maladresse*, but merely *je fais* ("I am," "I do . . . ," "shit on me": what a sequence, what a consequence, especially if one thinks that in French *je fais*, by itself, can mean "I shit").

Here now is the integral declaration of this *ego sum, ego facio*, of which you see, on this drawing, only the fragmentary remains:

[I am]
still too [young to] have

wrinkles. [I make these] children
of poor wrinkles and I send them to do bat-
tle in my body. —Only
I lack energy and this
is obvious; and I am still
terribly romantic
like this drawing that
represents me, *in fact*, too well,
and I am weak, a *weakness*.
[Shit on me].

Half-erased, this declaration belongs to the body of the work. But like a confession, an avowal of weakness that, moreover, begins by presenting, in this portrait of another woman, a self-portrait: it betrays *me*, myself, it awkwardly betrays the truth of my awkwardness, it unveils *me* in *my* weakness ("*this drawing* that / represents me, *in fact*, too well, / and I am weak, a *weakness* . . .").

But Artaud is not content to comment in the margins on this self-portrait of the other sex: he points it out. Gesture of pointing, deictic exhibition, stroke of ex-position: we see them operating, as is often the case, *right on the work*, in the space of the "emblematic" subscription or superscription whose analogy and subversion I have recalled. A bit of finger seems to fold back like a phantom limb on the subjectile: "*this drawing* that / represents me" (above that one reads "Here is a drawing"). A supplementary complication, this deictic performative, which points with the index while saying that it shows what it shows, can also be seen represented in turn, like a report that has been entered into the record (*dont il est pris acte*): this visual archive of an act or a blow says what it does, doing thereby what it says, but it records itself, with the same blow, in a representation. In French one would say that the one who draws *prend acte de son acte* (records or registers

his act). For *acte* also means the archive that keeps a legitimate and readable trace of what was done, deliberated, and accomplished. And especially—fold upon fold, abyssal performance in the hollow of the work, performative in performative—the deictic of this self-presentation doubles the confession or repentance of an order given to the spectator-voyeur, to the visitor to the museum: defecate on me, "Shit on me"; as for me, I make, here is what I make (children), so you in turn, multiple visitor, anonymous voyeur lost in the crowd, get into the act, don't look at me with your eyes, now shit, shit on me. "Shit on me" does not mean merely "take note of my fallen state" or "despise the dejection, decline, fault or failing, the weakness I have just confessed." For it has always been the case that, in numerous texts I have analyzed elsewhere, Artaud identifies the work with feces, which are children that one makes ("I make these children" [*je fais ces enfants*]: *fais-ces, fèces, fessée* [spanking]). He has thus assimilated defecation to making-a-work, which is to say as well to the gift, to the weapon, and to the phallus. To the *coup*. He even made of a certain fashion of saying *Merde* the trait of an address, an awkward, maladroit address of the drawing, a certain fashion of drawing well, in the *maladresse* itself, and of addressing well, as directly and adroitly as possible, the trait of the drawing. A good "fashion" to keep the capital "witness" of the *malfaçon*. Even though I had decided to make every effort to refrain altogether from retracing the steps of what I may have written in the past, over the last thirty years, on the subject of Artaud or even of his portraits and drawings, allow me one brief reminder for just this once (it will be the last time). Moreover, I will recall simply some lines of Artaud, and not what I have written about them, lines that I quoted once before in "Forcener le subjectile" (To unsense the subjectile).[9] They seem to me to respond in a very acute fashion to this "Shit on me" that we are trying to hear-see or to put to

the test in this museum. Three months before the *Portrait de Jany de Ruy*, in April 1947, several months before *Pour en finir avec le jugement de dieu*, Artaud let another "Merde" (Shit) ring out. He preferred it on this occasion not far from an apocalyptic "Last Judgment," which "alone," he said, "will be able to decide between values." He cried out "Merde" in a text that has since become famous for anyone interested in Artaud's graphic art, probably the most indispensable text along with the catalog for an exhibition in 1947 (*Portraits et dessins par Antonin Artaud*),[10] that fundamental piece of writing on "the human face," which should be studied syllable by syllable and to which I will return briefly in a moment. The text I am citing now cries out "Merde" to the adroit drawing, to the art drawing, to the world of art, its conservatory, its archive, its history, its museography, and finally to this "world here." Artaud does not say this "Merde" himself; he says, as you will hear, that the drawings say it. And this happens in the course of a scene that does not celebrate a centenary, like today, but ten times less, an act of birth only ten years old. It was the act of birth of an absolute drawer, of someone, Artaud Mômo, who no longer does anything but write while drawing, draw while writing, of someone for whom the *graphein*, the *zoographein*, as the Greeks used to say, the writing of the living, becomes the absolute manifestation.

Will it be possible to do what I am trying to do, to say "Merde"? Will it be possible, either with or without blasphemy, to read and to cite "Shit," "Shit to art," to do it then as must be done, in this great temple that is a great art museum and above all modern, thus in a museum that has the sense of history, the very great museum of one of the greatest metropolises in the new world? Here then is the *coup de théâtre*, the theater of cruelty of this "Shit"; the event is dated.

After the incipit ("Ten years since language left"), after the dating is duplicated a first time ("And ever since a certain day in October 1939 I have never written without also drawing"), and then a second time ("I say / that / for the last ten years with my breath / I breathe out hard, compact / opaque / frantic forms"), after the calendar of this graphic vow, if I may call it that, after the anniversary of this oath—to never again write without drawing at the same blow—after this periodization that would offer us a typological hypothesis with which to visit the exhibition or organize the reasoned chronology of a catalog, Artaud presents his drawing notebooks. It is a constellation, he says, thus a celestial light (we are not far from the lightning), which has already left the world, at least this here world. For it is on this here world that Artaud's drawings, from another world, unleash their excrement like bullets and say "Merde":

> Such are in any case the drawings with which I constellate all my notebooks.
>
> In any case
> the whore
> oh the whore,
> it is not on this side of the world,
> it is not in this gesture of the world,
> it is not in a gesture of this here world
> that I say
> that I want and will indicate what I think,
> one will see it,
> one will feel it,
> one will realize it
> from my maladroit drawings,

but so sly,
and so adroit,
that say SHIT to this here world.

What are they?
What do they mean?

The innate totem of man

The gris-gris to return to man.

 Instead of insisting one more time on the sly, twisted address of the badly done (the well-badly done) or of the declared maladroitness ("my maladroit drawings, / but so sly, / and so adroit"), I would like to pause for a moment, after a long detour, on these *gris-gris* in the vicinity of which I interrupted my quotation. Gris-gris are generally defined as amulets, cult objects. They are not meant primarily to represent. Through their form and sometimes through what they represent, beyond what they show, they are acts that are destined rather to produce an effect, to cast a spell, to strike a blow, to affect someone, to heal or kill, save or condemn. Gris-gris are efficacious works, operations that, beyond art, make a work. What, then, is the place of the gris-gris in the work or rather, one should say, in the existence of Artaud? They occupy a particular place and, at the same time, they are every place. They seem to cover the field that they open up. How so?

 If, by referring to the calendar that I have just evoked ("Ten years since language left, / since in its place / came in this atmospheric thunder, / this lightning"), one attempted, at least as a fiction, to scan the history of the graphic art signed by Artaud,

one would distinguish clearly two "periods." Let us say, first of all, two times. There would be the first time of the well-ordered or classic works, those in which is affirmed an admirable technical mastery, albeit apparently not very inventive. These are the landscapes in gouache from 1919, the still life, an oil from 1919, a series of studies, of portraits or self-portraits in charcoal, pencil, or pen and ink, from around 1920–23. This apparently "academic" period can be prolonged from 1924 to 1935 if one takes into account certain studies with an architectural or theatrical aim (for theater costumes or for the sets of the *Cenci*. The professional assurance of this art will never disappear, even in the second period, the more turbulent and striking one, which we are going to come back to. Until the end, until 1947, certain portraits will keep the mark of this skill, which one might in fact be tempted to term *academic* if Artaud had not *protested*, yes, protested (the word is his) and wanted to cleanse himself of any suspicion in this regard. Someone must have accused his portraits and self-portraits of academicism. After the fact (*après coup*), in 1947, at the heart of what it would be naive to call the second period, he revolts once more against this reproach, in fact, and takes refuge behind the reference to Dubuffet. At stake already, still, is the great question of the face as human figure:

> The human face is provisionally,
> I say provisionally,
> all that remains of the *demand*,
> of the *revolutionary* demand for a body that does not conform and
> never has conformed to this face.
> And don't come telling me that my faces are academic.
> Is Mr. Jean Dubuffet academic when he paints and when he

> protests
>> the nose under sockets
>> against the ocular academicism of present-day architecture
>>> of the
> face called pictural?
>> My portraits are those that I wanted to represent,
>> they themselves wanted to be,
>> it is their destiny that I wanted to represent without
>> preoccupying myself
> with anything other than a certain barbarism, yes, a certain CRUELTY outside any school, but who could find it again in the middle of the species?[11]

"My faces," "my portraits," he says, are not "academic faces," school studies, in-studio representations of figures that would be what they are. Artaud *wanted*, he says, to represent what these portraits themselves and these heads *wanted* to be; he wanted only their secret wanting. The cruel "destiny" of this will to will no longer belongs either to art or to the history of art, thus to what a museum can house, classify, exhibit, or expose. We will ask ourselves what "to expose" means, according to this destiny of cruelty, and it will be to ex-pose to blows rather than to the gaze. Likewise, there is no exposition, no representation, no presentation even or monstration, there is no *reference* or ferried gaze without *coup férir* (without striking a blow). The *férance*, the ferrying of the reference, the relaying of the relation comes down first of all to the violence of *striking a blow*, which in French we say with *porter un coup*, carry a blow, or with the more archaic *coup férir*. But it also comes down to the differance of this doubled blow.

For the moment, let us note that this protest against the reproach of academicism develops especially during the last

decade, thus during the second period, even if its premises are to be found much earlier, deep within what an untroubled history of art might call the first era, during which, moreover, Artaud writes a great number of articles on exhibitions. These form a corpus that deserves systematic study. One might then speak of the Salons of Artaud, following in a tradition that I will not venture to identify with that of Diderot or Baudelaire. A theory of painting is sketched out there through reflections on a great number of painters whose names I list in no particular order as they appear in these pages (Van Dongen, Suzanne Valadon, Matisse, Vallotton, Marquet, Renoir, Gromaire, Courbet, Cézanne, Manet, Odilon Redon, Bonnard, Vuillard, Dufy, Picasso, Braque, Foujita, Masson, Modigliani, Balthus, etc.), as well as on different "schools," impressionism, cubism ("which was new in its time . . . it is now necessary to change direction,"[12] a phrase one may read in 1923, written by someone who had already pronounced himself to be postimpressionist and postcubist). Tirelessly, Artaud was already putting in question the technical "skill" of the "doing/making" (*du "faire"*) and narrative painting, the "anecdote" (*OC* 2:182–83); as early as 1921 he praises what the "character" of a work "places above any technical question" (*OC* 2:199). We could, moreover, overinvest and generalize this word *character*. It would then designate the strike or blow of the *graphein*, the inscription of the imprint, the glyph (*glyphe* means blow), the "hieroglyph" that Artaud makes into one of the master-words of cruel writing and that joins writing to drawing, but also to the human face whose portrait grasps, in a "character," at the same time the mask, the figure, and the truth of a *persona*, the singularity as well as the type, the violent stamp of the *tuptein*. In the code of computers, one might say that Artaud already knew that writing is first of all what is called today an *electroglyph*. But he would have seen in the electricity of our writing machines

both an extenuation of living electricity and a violence turned back against it.

In the course of what I am still calling provisionally, for convenience, the second and last period, Artaud unleashes his defense against the accusation of academicism. He does it in the hollow or *creux* of the face, if I can say that, in the *creuset*, the crucible, of its *secret*, by digging into, that is, *en creusant* the enigma of the human face. As evidence, I take the extraordinary text that Artaud published in the catalog for the exhibition of his graphic works, which was also held (the date is still the same), in July 1947. This piece of writing takes up a single large page and now bears as title its incipit: "Le visage humain . . ." (The human face . . .). Because I am unable to devote to it the interminable and abyssal reading it calls for, allow me to situate a few possible headings for that reading.

1. I just used the word *abyssal*. Well, the abyss in the hollow of the human face, that is what Artaud wants to reveal, to give back, and to hollow out. To reveal in its truth, to give back and hollow out at the same time, for this truth is not given; it awaits the act, the trait, the stamp of the *graphein*. This has to do with the fact that "le visage humain," says Artaud in an admirable formula that is so difficult to translate, "n'a pas encore trouvé sa face" (has not yet found its face). He continues: "The human face, such as it is, is still in search of itself." In other words, Artaud does not want man to lose forever the face that he has lost; he wants finally to give it back to him, he wants to restore to the figure or face of man its truth. "The human visage has not yet found its face. . . . It is up to the painter to give it to him . . ." This logic of the *given* truth appeals thus to the gift of the face. Its cruel epiphany consists in returning by redeeming, for this gift still belongs to a logic of restitution (portrait of the trait for trait) as redemptive salvation. By giving figure to the face or rather by giving a face to the figure

or a side to the face, the painter renders and returns the truth, the truth that is life, by saving from death. Artaud had begun by saying that "the human visage is an empty force, a field of death"; a little later he adds:

> The human visage bears in fact a kind of perpetual death on its face
> from which it is up to the painter precisely to save it by rendering and giving back to it its own traits.

It is indeed in the hollow, in the crucible of the abyss that this *veri-fication* operates. It goes in search of itself in the generative and fertile cavity of a crucible, which presents first of all its negative figure: the hole, the bottomlessness of the abyss, the vault, the tomb, the place of death, or the crypt. The portraitist seeks to decrypt a truth, a truth to be rendered, returned, and given, to be *constituted* by *restituting* it, to be given in return even as it produces this truth for the first time: in the holes, the faults, or the cracks. For the first time in the hollow of these gaping holes. For the first time, in the first place, and in this first blow, there is no more, there ought to be no more room for an opposition, or even for a distinction between *constituting* and *restituting*, *giving* and *giving back*. The void of the orifice, chaos, *khaein*, the abyssal, gaping hole of the face with the opening of all its holes, of its mouth of truth, of its *hollowed out* eyes: that is the *secret* of this nondistinction that is unthinkable before the living force of the graphic trait and the blows it strikes. The word *creuset* appears here, moreover, before the double occurrence of its near anagram *le secret*. Elsewhere, glossing *La machine de l'être* or *Dessin à regarder de traviole* (Drawing to be looked at sideways), Artaud speaks of the "la tombe creuset secrète de l'homme" (the tomb secret crucible of man; *OC* 19:259–60). Artaud's lexicon—which

I am hastily selecting and cutting up in a rather barbaric fashion that destroys its syntax—then insists on the holes, voids, cavities, caves, on all the orifices of the face:

> The human visage is an empty force. . . . The human visage such as it is is still in search of itself with two eyes, a nose, a mouth, and the two auricular cavities that respond to the holes of the sockets like the four openings of the vault of approaching death.

Later the text will name once again those hollow openings that are "the arching vaults of the eyelids" and the "cylindrical tunnel of the two mural cavities of the ears," or yet again, "an empty eye, / turned back toward the inside."

2. If the truth of the traits restitutes as much as it gives, if it reveals and makes explicit as much as it invents what is not yet there, except as the hollow crypt of a vault of the body, this is enough to break with those great figures in the history of art that are, on the one hand, the naturalist realism of figurative painting and, on the other, abstract painting. Artaud claims to break with this history of art. He remonstrates successively against the one and the other of these figures of the human figure. He rejects once more the reproach of realist academicism, since the human visage has not yet found its face:

> it is absurd to reproach as academic a painter who, given the lateness of the hour, goes on stubbornly still reproducing the traits of the human face as they are; for as they are they have still not found the form they indicate and designate; and do more than sketch . . .

But, symmetrically, Artaud launches his invectives against that other academicism that is abstraction. He opposes cruelty with

its true secret of death to the surface secret of "nonfigurative painting." And the argument of his indictment, as you will hear, takes as its target the history of art, the whole history of art as history of the portrait:

> For the thousands and thousands of years in fact that the human face has been speaking and breathing
> one still has the impression that it has not yet begun to say what it is and what it knows.
> And I know of no painter in the history of art, from Holbein to Ingres, who has succeeded in making it, this face of man, speak. The portraits of Holbein or Ingres are thick walls.

What they are lacking, in sum, is the lack formed by the abyssal holes and the vaults of the gaze.

I know of only one exception to the counterhistory that Artaud is telling himself in this way and that he launches, like a missile of war, against the whole of art history. In this filiation there would be, more or less, only one work, there would be only one avowed figure of a legitimate and legitimating ancestor who, as Dubuffet did a moment ago, offers his backing and support. It is *La tête de Van Gogh au chapeau mou* (The head of Van Gogh with soft hat) that

> renders null and void all the attempts at abstract paintings that might be done after him, until the end of all eternities . . . [In other words, *La tête de Van Gogh* destroys or neutralizes in advance all an-eventual posthistory, all the *après-coup* that any sublating succession might claim to guarantee him, for example, in other schools such as abstraction.] The head of Van Gogh . . . completely exhausts all the most specious secrets of the abstract world in which nonfigurative painting can indulge itself,

that is why, in the portraits I have drawn,
I have avoided above all leaving out the nose, the mouth, the eyes, the ears, or the hair, but I have sought to make the face that was talking to me tell
the secret
of an old human history that passed for dead in the heads of Ingres or Holbein.

3. Once again, everything reverberates in the *coup*. In the explosion of a blow. The force of the blow, in seeking its place in a cavity, will always be a force of perforating percussion. One will not see the face of Artaud unless one hears the blow reverberate. I am saying "reverberate" or "resonate" so as to insinuate my argument, namely, that the blow is a *double or duplicated blow* that is its own echo, insisting and remaining and surviving in this way (like the "fashion" we were talking about a moment ago, which permits the destructive *malfaçon* to "remain"). That the unique and instantaneous blow is originally a duplicated, reverberating, echoing blow is what permits destruction to save the possibility of what it ruins: for example art and the museum. For lack of the time necessary for a minute demonstration, allow me simply to let you hear the reverberation of the blows in "The human face . . ." Like the implosion of so many others, whether or not I have cited them, their noise is consonant with that of lightning, firearms, rifle shots, rockets, or charcoal, the *fusées* or *fusain*, which carry this force of a phallic head thrown against a parietal surface, a material support, a subjectile that will very often take on the maternal but also paternal figure of the Christian spirit, of the holy family, and of the father-mother. Listen to the shock waves of these battleground conflagrations on a single page and the pounding of the bombardment and the explosion of a rocket and the cannon shot.

a. In search of their form, "the traits of the human face . . . from morning to night, in the midst of ten thousand dreams, pound as in the crucible of a passionate palpitation . . ."

b. "Only Van Gogh was able to draw from the human head a portrait that was the explosive rocket of the beating of a shattered heart. / His own."

c. "For this avid butcher's face [it is still a question of *La tête de Van Gogh*], projected like a cannon shot onto the most extreme surface of the canvas, / and that suddenly, at one blow, sees itself arrested/ by an empty eye, / turned back toward the inside . . ."

You have just noticed the counterblow of the blow that, in one blow, comes to arrest another and thus both to multiply it and divide it on the surface of the canvas. It is the implacable and cruel logic of this double blow, of this blow duplicated as counterblow,[13] that seems to me to intensify the cruelty, to make it cruel by itself and for itself—and, by the same token, *du même coup*, to destine it to make a work, a work that is archivable because iterable, in the museum and in the history of art, in the Christian family, its law, its capital, its state, all of which the work attacks and pursues with its hounding traits. But for there to be iterability of the duplicated blow, and re-percussion of the perforating percussion, there must be the singular event of the blow in its indisputable occurrence. And in the most didactic self-presentation of his graphic work, in its self-manifestation, Artaud never dissociates the act and the blow, the act of *giving* and the act of *giving blows*, the gift of blows and the gift of the truth, in other words, of the very manifestation of the truth, of its self-presentation from the source (*sponte sua*) through the "spontaneity of the trait" drawn or the blow struck by the one who signs Artaud, sealing thus the destruction of the concept of the work and thereby of the museum, the agony of an art that,

nevertheless, at the instant of its death, will perhaps survive its own apocalypse:

> I have moreover definitively broken with art, style, or talent in all the drawings one will see here. I mean to say woe to whoever might consider them as works of art, works of aesthetic simulation of reality.
>
> Not one of them is properly speaking a work.
>
> All are sketches, I mean *blows of a sounding rod or a buttstock struck* in all directions of chance, possibility, luck, or destiny.
>
> I have not sought to refine my traits or my effects,
>
> but to *manifest in them kinds of patent linear truths* [I underscore this manifestation of the truth according to lines or lineages], whose worth is as much in the words, the written phrases as in the graphism and the perspective of the traits.
>
> It is thus that several drawings combine poems and portraits, written interjections and plastic evocations of elements, materials, persons, men, or animals.
>
> So one must accept these drawings in the barbarity and disorder of their graphism, "which has never been preoccupied with art," but with the sincerity and spontaneity of the trait.[14]

Perhaps you still remember that I had promised to return to the "gris-gris," to what Artaud himself calls, in the cited passage, "Gris-gris to return to man." What is the time of these gris-gris in view of the return to man? What fate [*sort*] can we find for these *Sorts* (Spells)? What is their history and in what way do these bearers of blows also, and with the same blow, bear the question of the blow? The insistence of the doubled blow now leads us to complicate, in truth to disqualify, the concept of a history of art, thus of what founds this foundation that is a museum, namely,

the concepts of art and of the work that are indissociable from the museum. One must also therefore dispute the rigor of a periodization in the graphic work of Artaud. In fact, another period or time, the third time if you like, would have come along first to blur the distinction between the two sequences I evoked a moment ago: *first* the time of disciplined training, during the 1920s and 1930s, which is to say the school exercise, the period of relative conventionality, of quasi realism in which is evidenced the maturity of a tested technique, and *then* the time of insurrection, the creative mutation, the seismic upheaval, which, after the electric lightning strike of 1939, after language has "left," and especially from 1945 to 1948, the year of his death, would have given birth to a powerful, ingenious, and abundant graphic progeny; the latter, in fact, will increase by more than a factor of ten the earlier corpus by placing itself under the sign of the Mômo and of feigned or sarcastic awkwardness. This other time, the third one, but in chronological truth the second, would also come to wedge itself between the two others and ruin the very principle of a succession or a historic calendar of the works. This supplementary time would thus be neither a historical time nor properly speaking a third estate of Artaud's revolution. If it was a third, a *terstis* (*testis*), it would be the capital witness of what happened before and what will still happen after, namely, the graphic act as blow, the event of a performative perforation that seeks to produce effects beyond what it destroys, transgresses, pierces, namely the support, the work, the wall of the institution, the policed hospitality of the hospital or the museum. From 1937 to 1939, in the *suspension* of this intermediary *epoch* between the two hypothetical sequences, we know that Artaud made many of what he himself called *Sorts*. These require an infinite analysis infinitely adjusted to the singularity of each one. Unable to meet that demand here,

I will note certain of their common traits, beginning precisely with *singularity*.

For *in the first place* each of them is not only dated, like most of the other drawings, but constitutes a unique event whose *relation* to the date is in principle irreplaceable. It is with *reference* to what happened at one blow, on such and such a day (for example, the visit of Roger Blin to Ville-Évrard on May 21, 1939), that the *Sort* is transmitted, like a dated missive, to such and such an addressee, who is also unique and apostrophized by the *Sort*. This unicity of the reference to the event and the destination makes of the *Sort*, *in principle*, a singular gesture, a weapon with a single shot, the commotion of a single context. It is not first of all, *in principle*, a work of art destined to be exhibited or preserved in the conservatory of a museum, if one leaves aside for the moment remaining [*restance*] and iterability, the duplicated blow and the good "fashion" of the ill-fashioned [*malfaçon*], the making [*facture*] of the well-badly-made that I was speaking of earlier—and that complicates everything.

Second, these *Sorts* are not essentially artistic representations destined for the gaze. They are meant to change the world and to produce psychurgical or magical effects there on real things and people, not on virtual visitors. Not necessarily on the addressee in the circumstance, for example Roger Blin, who is here the guardian or mediator of threats addressed to others.

Third, these promises or threats addressed to persons, personages, or "characters," assume a form that is both discursive and physical. Discursive through sentences such as

> *I send a Sort to the First person who dares*
> *to touch you. I will crush to a pulp*
> *his little false-strutting-cock snoot.*
> *I will whip his behind [fesserai] in front of 100,000 people!*

This threatening promise was followed by a pictural evaluation that incriminates the very voice of the painter. When a painter is bad, it is his voice that is to blame:

HIS PAINTING WHICH NEVER HAD ANYTHING VERY STRIKING ABOUT IT HAS BECOME DEFINITIVELY BAD. HE HAS AN OVERLY UGLY VOICE
HE IS THE ANTICHRIST.

This address in language always accompanies a gestural intervention, an operation of the hand, or even of a firearm, a sort of lightning that attacks the very support of the *Sort*, miming or preparing blows striking the addressee. These blows consist in making holes, perforating, piercing, and above all burning the subjectile. These struck and duplicated blows are, moreover, called by their name (piercing and burning perforation) and the support of the work occupies the place of a target. The subjectile is the subject aimed at, for example in the *Sort* entrusted to Blin:

> All those who
> have gotten together, to prevent me
> from taking some
> HEROIN
> all those who have
> laid hands on Anne Man-
> son for that reason
> on Sunday
> May 21 1939, I will
> have them pierced alive
> in a public square in
> Paris and I will

have their marrow
perforated and burned.
I am in an Insane
Asylum but this
Madman's dream will be
realized and it will be
realized by Me.

<div align="right">Antonin Artaud[15]</div>

Fourth, these *Sorts* must not be acts of witchcraft but, on the contrary, exorcisms, rejoinders to a malevolent action, conjurations meant to undo a spell, counterconjurations, antidotes to the spectral, to the mystical or initiating process, the constant battle of a polymorphous and satanic pervert for new Enlightenments. Artaud writes at least two times that the *Sort* "breaks any spell."

Fifth, and finally, the counterconjuration, the counterinitiation, the efficacity of the spell cast by the *Sort* is not only real, it not only burns through any aesthetic simulation, it must be *immediate.* But this immediacy must *last,* and this is what exposes it to its institutional drift, this is what destines it despite itself to *remain* and to alienate itself in a museum: bearing death in life, unable to tolerate any relation, any delay, any differance, any translating mediation, this immediacy must be current, nonvirtual, *eternal.* It will last until the end of time. Artaud writes this at least two times. To a woman he writes:

You will live dead
you will not stop
passing away and descending I cast you
a Force of Death.

> And this *Sort*
> will not be brought back [*rapporté*].
> It will not be
> postponed [*reporté*].

Then to a man:

> And this *Sort* will not
> be brought back.
> It will not be
> *postponed*.
> The efficacity of its action
> is immediate and
> and *eternal*.
> And it *breaks* any
> spell.

For the reasons I have said, this eternity, this enduring of the duplicated blow exposes the spell to the museographic archive, but the latter, which Artaud feared, did not prevent him, precisely, from denouncing the Museum as the malevolent agent, as a conjuration that had to be in advance counterattacked and counterconjured. In one of these last *Sorts* (the very last one, right after the declaration of war in September 1939, was addressed to Hitler, held to be an "initiate"), Artaud explicitly accuses the Museum of witchcraft. This is perhaps even the only time he names the Museum, which I suggest provisionally until an inventory is done, and he does so in order to point to it as the force of Evil (*Mal*) and the privileged adversary. This accusation is made when he ironically addresses the *Sort* to the man of the Museum, to the gallery of collectors and curators. It is the act of a cultivated Mômos,

a more satanic and sarcastic blow than ever. Artaud assaults and insults the "connoisseur of spells and other magical curiosities" who would also like to collect the *Sorts* for his museum. Here is what can be deciphered on the recto of this *Sort* from May 16, 1939:

> Sir,
> Knowing you to be a great connoisseur of
> SPELLS and other magical curiosities I send you this SPELL which
> constitutes a MAJOR
> EVIL-DOING CONJURATION
> AGAINST ALL ILL-INTENTIONED
> BEWITCHERS.
> It is not part of the
> Museum of Magus Sorcerers and AL-
> CHEMISTS.
>
> <div align="right">Antonin Artaud</div>

There, in sum and at the end of this announced long detour, is what is said and done as well by those words that Jacques Prevel confessed to having erased. Artaud's mimed and contradictory confession ("and I am weak, a *weakness.* / [Shit on me]") calls up in turn the confession of a misdeed committed by the picture's first spectator, Jacques Prevel, who would, first of all, have attempted to intervene on the work, to lay hands on it, and to retouch its form and meaning, to countersign it in some way. Now, it pleases me to remark here a singular fact, a magical dramaturgy, a coincidence, both calculable and by chance, of dates, subjects, and acts. Today, as I was saying, we are July 2, 1947, the date of the *Portrait de Jany de Ruy*, date as well on which Prevel transcribes, erases, and in some way steals the words that we have just restored but that remain unreadable on the picture. Well, several months

earlier, Artaud had done two portraits of the same Prevel, on April 26 and May 11, 1947, the one full-face and the other in profile. He was doing more and more portraits at this time, less than a year before his death. Now, what does one read on the first of these two portraits, the one that Artaud will later entitle, on a list, *Jacques Prevel forçat* (Jacques Prevel convict)? One discovers there a kind of accusation or malediction, a sentence that at the same time seems to put the blame in advance on Prevel for the Sin of which he will prove guilty and confirms that for Artaud every work, and especially every portrait, signs a long-distance blow. This operation of the opus seeks to be efficacious and at work on the subject itself; it punctures and burns the canvas so as to reach the model as well as the spectator, so as to leave the mark of a contusion, in their eye and on their body: in a word and first of all in their face. As I suggested a moment ago, the intentional *reference*, the relation, address, or designation never happens without *ferrying* a blow [sans coup *férir*]. And the blow is posted first to the head, to the posture of the head in the portrait. So there were two portraits of Jacques Prevel, one in profile and the other full-face. On the one that shows the subject full-face, a sudden apparition of Marie in the heart of the name:

> If Jacques Marie Prevel could only know the Sin
> that crushes him and I, who do not believe in Sin, I say the
> Sin placed on him Jacques Prevel crushes,
> let Jacques Marie Prevel not commit the
> Sin that his whole face meditates [overwritten on
> "premeditates"],
> that in him Marie premeditates against Jacques Prevel.

One of the multiple readings of this graphic injunction ("let Jacques Marie Prevel not commit the / Sin" that Marie

"premeditates against" him in him, that is, right in the middle of his name and his head and his face) is that Marie is at fault: the sin is first of all hers. The act of the portrait, this sort of action drawing, Mômo's act, Mômo's art, the counterblow of the trait must foment a counterconjuration; it must exorcise the Holy Spirit as well as the Virgin born of the Immaculate Conception who comes to poison Jacques's body. As always in the drawings and portraits from this period, as I have tried to show elsewhere, at stake is the history of sexual difference, of its Christian appropriation or perversion—inasmuch as that history is tied to perversion and to the museo-christographic appropriation, the museo-eucharistic transsubstantiation. Along the left border of the same portrait, satanic madness is named, the temptation twice mentioned at the heart of the One, of the Androgyne, and of the couple of sexual difference. All of this is figured doubly: in a figure and in a face, one word per line:

> The Androgyne / broken / down / took / back / the one / and / tempted / it / with / man / but / it's / that he / tempted / it / with / woman / at / the / same / time / and / Satan / the / madman / was / everywhere.

But most of the words in the self-portrait of the other woman (*Jany de Ruy*) remain legible, in particular the apparently insignificant sentence with which it all began, here, today: "And who / today / will say / what?" It is signed "Saint Antonin," sealing thereby the *amusement*, the irony of the god Mômos, the mockery of historico-academico-museal self-canonization. Of course, saying almost nothing, this signature announces nearly everything, singularly "the whole of the other" (*le tout de l'autre*). And as opposed to the fallen humility that will follow and precipitate, apparently, the falling off of the drawing, Saint Antonin goes to

the summit of *hubris*. The index of a first deictic ("here is a drawing") plays at going beyond the peak of the masterwork and the head of the master of masters, Leonardo da Vinci in person:

> Here is a
> drawing
> that
> goes beyond
> and way
> beyond
> Leonardo
> da Vinci
> but it is not
> above all by
> the drawing by the
> whole of the other [*le tout de l'autre*]

and on the facing side, along the bank of blue:

> And who
> today
> will say
> what?
> Saint Antonin.

Here perhaps is an inspired response to the suspended question, an amused retort to the question of the museum, a declaration signed by a drawer-painter-poet-actor-thinker who canonizes himself, Mômo's act, Momact in expectation of an art museum, of a Momart, of a Momartaud. By canonically signing his assumption or ascension, "Saint Antonin" with the same blow raises himself through drawing above the master of masters, Leonardo da

Vinci, even as he denies doing it with the drawing, and even with a Work of Art signed Artaud.

Overtaken by surprise and drawn tight by the twisting of this gesture, the affirmative force of this denial takes form and makes a work. To say there is only denial in the good-badly-done of this *malfaçon,* as in the whole of Artaud's oeuvre, is neither to diagnose nor to denigrate; it is to put the structure of denial into question and *en abîme.* For perhaps one should ask (and thus begin to perceive) what happens when the ironic reaffirmation of a hyperbolic denial of denial crosses the limit: when doing so it *makes a work (fait œuvre)*—and one that *remains.* Especially when it puts itself to work in the corpus of a unique operation, the necessary chance of a blow, the pulsation of a pulse, the compulsive impulse that tries to remove itself from the history of literary, graphic, or pictorial works. This work is not exhausted in a discourse. As you see here, it overruns this discourse, which it inscribes within itself; it assumes form as a body in a single but duplicated blow; it gives itself its own body one single and unique time in an event that is both irreplaceable and serial, divided or multiplied in its insistence on reconstituting the support by destroying it. The event, at the moment of signing, recognizes no soothing status for itself, no assured stability: neither as drawing, be it a drawing by da Vinci, nor as work of art in the tradition of a history of art or of a filiation of masterworks, and still less in the cult or the culture of a museographic canonization. That is what I wanted to suggest here today.

"Today," he writes in 1947. That day in July 1947, where were we? It was another day, in bygone days, another today.

Where are we today? The day of today? This evening? We are within the walls of a MoMA. What is a MoMA? What does museum of modern Art mean? A Museum of Modern Art? In this very place, who would take place? To say what?

Here, this canonizing institution, this place of sacralizing legitimation of modern times, this pyramid of father-maternal and speculative commemomarketmummification, we call it, then, MoMA, M-O-M-A.

OA/AO, AntOnin ArtAUD, ARTO, ARTAU, he, Antonin Artaud, the name of the one who sometimes signed himself Saint Antonin and who signed all the works exhibited this evening at the MoMA, Artaud, itself, this predestined name that carries and carries within it like an unborn child the *art* that it nevertheless attacked with heavy *hammer* blows (*des coups de* marteau) and other missiles or projectiles of war, he had more than one fate in store for this name bequeathed by the pair of his father-mother and spelled it in many fashions. *Pollakos legomenon*, as his Greek ancestors might have said, this name is pronounced and written in more than one way. Sometimes Artau (A-r-t-a-u), sometimes Arto (A-r-t-o). One day he called himself, and it was more than a nickname, Artaud le Mômo, or in what was one of his last texts, in 1947, Artaud-Mômo. These two names then came to form a single one around a hyphen, a little like the pair of the father-mother in the writing-painting *L'exécration du Père-Mère* (1946).

One will understand nothing of Artaud's visual work if one does not hear his voice, if one does not attune oneself to the tempo of his letters and the rhythm of his words beyond coded language, beyond its grammar and its instituted semantics. Inversely, and this is the whole aporia, one will understand nothing of this transgression of coded language, of what sets out from language by separating from it, if one does not set out from the language it separates from, here the Greco-Latin sedimentations in French with which his glossolalias are still consonant in the disadjoining of their dissonance. One must therefore, and beginning more than ten years ago, take leave *from* and *beginning with* language.

That is why I wanted first of all to let reverberate some of those into-detonations before beginning.

But also, by the same hypothesis, one will gain no access to Artaud's drawings and portraits if one does not read all its traits according to the secret grammar of this hyphen or *trait d'union*, of this trait of union and its double. For there is one single but double hyphen: on the one hand, the one that solders, articulates, couples without other copula the pair of the two names father and mother, which Artaud writes so often, especially at the end, as a single word, *father-mother*, but also, on the other hand, the hyphen *Artaud-Mômo*.

What is one doing when one forces one's name? And when one forges it otherwise, letter by letter, at the bottom of a crucible overflowing with vowels to be regurgitated? You have noticed that the consonants *RT* in his name are untouchable, intact, immune, like, moreover, the syllable *ART*. ART does not move. As in *Momart*, in sum. *Art* resembles a word that is whole, safe, intangible, integral. But an insignificant word, the body of a word emptied of its legitimate meaning. For as soon as the word *Art* takes on its common meaning again, as soon as it again becomes a word one traverses on the way toward an accredited concept, art—the art of fine arts, the art of Churches and Museums and Markets—then the bearer of the name, Artaud, is not just content to denounce it, to hurl invective at it; he strikes it with hammer blows. He strikes it to death.

Before pursuing this reflection on what the literal seismic tremors within the signature *Artaud* import into the work of his called "visual," allow me to open a parenthesis on this parenthesis that Artaud wants both to open and to close—regarding art and the history of art. The history of art is a parenthesis put into parentheses, the epoch of an epoch, and even a parental parenthesis. The innumerable protests against art and against the work

as work of art would allow us to see Artaud as a contemporary of Duchamp if so many differences did not make this a shocking analogy. Among many other dissimilarities between these two great figures of the century, there would be, not a continent (for there is also a good America for Artaud, precolonial America), but the United States of America and everything that is colonized, capitalized, canonized, capitanonized there in museographic speculation. The blasphemous imprecation, the interjection on appeal, the inflamed accusation are aimed sometimes against this thing called Art, sometimes against the Work as Work of Art, sometimes against History as history and Holy history, the Christian history of art. A powerful discursive writing runs throughout Artaud's drawings and portraits, but we could support what I have just said about the three assaults of insults (against art, the work of art, the history of art) by evoking once again the only catalog text that Artaud himself wrote in 1947 for the first exhibition of his *Portraits et Dessins*. This war against the history of works of art is conducted, as we've read, in the name of a thinking, or one should say rather an *experience*, of the face. It is in the name of the face that Artaud declares war, in the name of all the faces that one must learn to see right here, in the name of a face to come, of a "human visage" that has not yet found its "face": "Which means that the human visage has not yet found its face." When Artaud leaves and separates himself ("I have moreover definitively broken with art, style, or talent in all the drawings one may see here . . ."), this assertion is not a calm theoretical or autobiographical declaration; it does not merely relate the event of a break with the art of fine arts, with concern for beautiful form, for style, for arrangement, for aesthetics linked to know-how, to skill, to formal training, to the technical experience or experimentation of a talent. No, this assertion is not a description or a theoretical observation; it is a declaration of war, the trait, the

flaming arrow, the portrait of a vociferation, the drawing of a cry of conjuring malediction that, as *all* of Artaud's drawings have always done in a certain way, threatens to strike a blow, in truth, strikes it already and casts a spell. The blow exerts an immediate magical action against those who would think otherwise. By means of an oath signed right on the work, an oath that makes a work, a pledge that makes a work, this conjuring operation consists in calling up revenants or ghosts, in convoking them by dismissing them, within oneself and outside oneself. In the same ex-pulsing impulse, the same compulsion whose pulse comes to push at the same time, in a rhythmic pulsation, toward the outside and toward the inside. An avowed, incarnated denial pushed to the extreme, ready to destroy everything, including the dust and the powder, exorcisms, conjurations against conjurations: to cause the latter to come by expelling the former. It is less a matter of convincing than of worrying, affecting, transforming the aesthete's body, of changing these transient guests who, having come as visitors or voyeurs into a museum, would claim to be mere spectators. Woe to these contemplators and consumers of images. Woe to them, says Artaud, woe to those who are interested only in art, in beautiful fictive representation:

> I have moreover definitively broken with art, style, or talent in all the drawings one will see here. I mean to say woe to whoever might consider them as works of art, works of aesthetic simulation of reality.

Those he dooms to woe and misfortune, those onto whom he calls down a sort of countercurse, are his incorporated doubles, his others, with all the hellish fiends he called parasites, golems, specters, vampires, angels, and spirits from a "fucking rubbish heap of a beyond" (*au-delà de foutaise*) (*OC* 12:48, 197–98).[16] The

fucking rubbish heap of the beyond, thus of the spirit, the fucking rubbish heap of the "perisprit" of the father who circles around with his good-tasting sperm, never escapes the lightning bolt mockery of the Mômos who knows how to play everything for a fool (*se foutre de tout*)—which is to say, to deny, or, I would prefer to say, *dis-avow* persecution.

In playing with the spelling of his name, Artaud was also doing still other things. In permutating the vowels, the vocabulary, and thus the voices of the ones and the others, he was drawing while he wrote, he was interweaving the play of the phonemes with the lines of the trait, between the words, syllables, and things. Elsewhere I tried to follow the necessity and the force of this gesture, in particular around the syllable *RA* or *AR*, which one finds again in Artaud but also, here, in *dira:* "Et qui/aujourd'hui/dira/quoi?" "And who / today / will say / what?").

The turbulence of the proper name agitates only the play of the final vowels, *A* and *O,* at the end of the family name. To be sure, the vocal couple *AO* remains in place (ArtO, ArtAU), while the visible spelling of the second syllable, with *O* or *AU,* becomes one time *AU* all by itself without *D,* another time *O* without *A,* another time *TOT* (precisely so as to designate "powder," cannon powder, I suppose, or gunpowder, *poudre* like *foudre,* as well as seminal dust or the germinal pulverization that reengenders the world, from out of the primeval volcano, the lava soup at the moment of life's creation, then the mutation that gave birth to the unique man: "some powder of ARTO, / some powder of ARTOT, / some powder of Artaud / to redo the creation"). But *AO* is never inverted into *OA,* the way Mômo seems to be feminized or maternized into Moma. Paule Thévenin has insisted on the impulse to masculinize or phallicize the proper name by replacing *AU*(*D*) by *O,* which is, she says, "more affirmative" and "more male" than "the *a* sound," which is "stretched out" and "more insipid."

She writes this just after citing a passage from August 1947 where the "gouffre Arto," the "Arto gulf," "innate son of God on earth had no other boast on his lips than to bugger all of male creation," in opposition to Jesus Christ of whom he writes, "the only courage he managed to show / in his life was to get himself sodomized to death, / while sodomizing others very little, / except in dreams and from afar." This is another figure of the sexual maladroitness of god, another manner in which to designate the false virginity of jesuschristianism, the holy spirit or the trinity, the father-mother-virgin son, as the enemy, the other, or the double to be conjured away, the bad witchcraft associated with the Museum. In a very fine text that I have just read, Werner Hamacher demonstrates that, for Benjamin as well as for Heidegger—whose ontology, he argues and as I have long suspected in another way, is marked by a disavowed Christianity—one must even speak of an ontology of the Virgin Mary, of a "Christian meterology."[17] The Museum, he argues, remains a thing of the mother; I would say that it holds the place of the mother, the place (thus the trope or the figure) of the mother, *in the place* of the mother. Even in its dematernizing, decontexutalizing, defunctionalizing function, beyond the Benjaminian opposition between ritual cult value and exhibition value, it is heir to what Hamacher calls a "metaphor of the mother," its *meterpher*. Might one not find a supplementary indication of this, I asked myself, in the appellation *Moma*? The museum that bears this name, and, par excellence, the museum that sports its initials, would thus be the matriarchal paradigm of a familial genealogy that has become *res publica*. But can't one say as much of "Metropolitan"? Modern or classical, every museum would thus be metropolitan—therefore also as maternal as the city or the *polis*, the state, capital, or the capital city that are always safeguarded, concentrated, accumulated there, that specularly and speculatively watch each other there. There would be much to say in order to situate Artaud's gesture in this regard, as well

as about what distinguishes the movements analyzed by Hamacher as concerns Heidegger (who is moreover named by Artaud, whether he read him or not),[18] but also about Benjamin, Hawthorne, Proust, or Valéry. One of the differences would perhaps have to do with the fact that Artaud's execration is not aimed solely at the museum's witchcraft as Christian *maternity* and immaculate conception. It is also aimed at the paternity of the father in the pair *of the* father-mother. We must never forget that the blasphemy "I shit on the Christian name" is addressed to the Holy Father in the *Adresse au Pape* (Address to the pope) that in 1946 Artaud wanted to make the preface, the in-your-face frontispiece of his complete works (*OC* 1:13). In the jesuschristianism that inspires our history of art and the spirit of our houses of worship, which have been disaffected or reaffected as museums, the execration execrates, in the first place, the holy spirit, the trinitary mediation of the holy family and the father-mother couple, as a maladroit, dephallicized coupling of two spirits and two glorious bodies. The trait of his drawing, when it strikes a blow, aims at the hyphen or trait of union of the father-mother, of the pair that holds these two together as one (*uph'en, hyphen*). And before this spiritual couple, before even Mary, the blow is aimed at the Immaculate Conception that castrated man, the male rather than the woman. Around 1943, the unsigned and undated drawing that bears this title, *L'immaculée conception*, shows once again a phallic cannon, equipped this time with testicles, in the center, and along its edges one can read:

> the immaculate conception
> was the assassination of the principle
> of MAN who is a cannon mounted on wheels.

One can always ask oneself what happens—life or death, one and the other—when a body puts itself to work, into a work,

then when, letting itself be identified, it sees itself classified, celebrated, or mummified as work of art, then saved, immunized, safeguarded, embalmed, accumulated, capitalized or virtualized, exposed, exhibited in what we will continue to call, for a little while longer, a museum.

But one can also ask oneself who is coming and what is coming, what is happening to a museum when it thinks it is housing or even exhibiting Antonin Artaud. And when it allows, this evening, even the reproduced and virtualized voice of Antonin Artaud to reverberate within it.

A terrifying enoblement of Saint Antonin. The quasi canonization that lays in wait for him here, in this great march of the symbolic market, from Paris to New York, from capital to capital, metropole to metropole—after the pomp of Pompidou, MoMA—is perhaps the most formidable ordeal for the specter, for the "infant revenant" named Antonin Artaud.

But let us hang on to one hope. Where there is not the father and the mother, the name of the father and the name of the mother, there is *le* father-mother. Artaud takes it to be masculine, as if it were still a man, or else neuter, like a mechanical apparatus, a prephallic instrument whose indifference would claim to be older and more powerful than sexual difference. Moreover, doesn't he say as much in a very enigmatic fashion?

> Well I am the father-mother
> neither father nor mother,
> neither man nor woman,
>
> I have always been there,
> always been body,
> always been man.

(*OC* 14:60)

Now, by housing today a picture of Artaud-Mômo's titled *L'exécration du Père-Mère* (April 1946), MoMA has become pregnant in an untimely way with a suicide grenade whose detonator has been generously but also very ingenuously entrusted to me. Naturally, I will not pull the pin, not right away, because the time of these invisible and unforseeable explosions must remain anachronistic. As I suggested earlier, the doubling of the blow struck against the support and against the wall of the Museum, the repercussive iterability of the blow in general destines to the remaining of the Museum—compulsively, inevitably, fatally—whatever claimed to put it in a bad way through maladroitness and the address of the maladroit, the badly well done, the good fashion of the ill-fashioned. A museum still keeps the trace of the blows it receives. It keeps it and keeps itself from them, is beware of them, like the truth (keeps itself from) the truth. A *coup* against the state thus becomes once again a simple coup d'état, the replacement of one state by another. It is nothing more than the substitution of one metropole, one capital or capital city, for another.

Like that of the museum and all it carries with it, the Artaud explosion has been underway for a century, as we know. It is a chain reaction whose anniversary we are celebrating today: Artaud would be exactly one hundred years old today, for he was born (as was my father) one day in September 1896, September 4 to be exact (like one of my sons). The drawing *L'exécration du Père-Mère*, in other words of the Museum, also bears the title of a magnificently elaborated text that dates from 1946. This text is contemporary with "Ci-gît" and "La Culture indienne" (Indian culture). Like "L'histoire vécue d'Artaud-Mômo," "Tête à Tête" (The lived history of Artaud-Mômo, Tête à Tête), all of these texts would require a slow, careful, inflamed, vocalized reading, preceded by subtle and audacious protocols of interpretation. One Monday in January 1947, Artaud gave the nickname "Tête à Tête" to a representation at the Vieux Colombier theater. The metonymy

of this title, "Tête à Tête," could orient but also disrupt all the methodological protocols in the world. It is made, badly well made, to send them astray among the operated permutations, the grieving and persecuted perforations, the perversions of a polymorphous impulse that, with each blow struck, forces one to become what one is no more, sometimes there where one was not yet, incorporating one's other at the moment of expelling it, ex-posing it to the outside while interiorizing it, calling thus in the name of the other and while calling to the other, while interjecting an appeal against oneself—and all the way up to god. The mourning for this god, the incorporating ex-impulsion whose cost and blows (*le coût et les coups*) are borne by the lightning of these drawings, ruined by the powder of these colors: these no longer pertain to a psychology. Unless we conceive a psychology of god and likewise a psyche of Artaud Mômo, whom we would then listen to and call to appear as a witness:

> Over and above the psychology of Antonin Artaud, there is the psychology of god, the master of masters,
> and you are not the master,
> you do not know what has to be done.
> Well, this psychology happens in this body of mine, me, Antonin Artaud . . .

Or still earlier:

> Over and above the psychology of Antonin Artaud, there is the psychology of another
> who lives, drinks, eat, sleeps, thinks, and dreams in my body.
> I do not live in a council of heads,
> I do not think in a cenacle of spirits.

These heads and spirits want to expel him from his own body, right here, here again, at MoMA. Prick up your ears, listen to Mômo listening to these heads and these spirits, on the same page:

> What are you doing there, Antonin Artaud?
> Yes, what are you doing there? You are bothering us.
> And finally get out of your body, it's for us to take your place, you've
> held it for too long . . .

(*oc* 14:189, 71)

Unable to venture into it, unable to lead you into it here, I will do no more than outline a task and formulate a warning: without the experience of these texts, without meditation on these protocols, without recasting everything from top to bottom, in one's own body as well as in the body of the other, using hammer blows but also the finesse of the most virtual lasers of a thinking to come, without rethinking the boundless question of the relations between symptom and truth, folly and fire, art and lightning, *foudre* and *poudre*, without this senseless and incensed revolution of self, one cannot engage oneself body and soul in the experience of the drawings that are here passing through, hung up like flayed animals (*accrochés comme des écorchés*) on these walls. If one does not run these risks, then at most one can indulge in some aesthetic tourism—and take a walk like a hurried connoisseur or a sleepwalking collector in the distinguished galleries of a museum that, for its part, and for this we must pay tribute to its curators, did manage to expose itself to all these wagers. But without courting these dangers, one would accede to neither the alpha nor omega of this event, to the doubled blow of what is held in reserve here,

or even to the question of knowing whether one must begin or end with the alpha or the omega, with A or with O. Especially if one wants indeed to wonder who is calling whom and how Artaud is called when someone addresses himself with an abrupt apostrophe in his tête-à-tête, wondering not "And who / today / will say / what?" but:

> Well, what do you yourself say
> yes, you,
>
> ARTAUD
>
> what do you say, you?
> you, about all that?
>
> ME?

(*OC* 14:20)

This doubled Artaud was interrogating a kind of ghost of himself, already, in a text from 1946 titled *Interjections*. It often happened, as we know, that he designated or drew Artaud as another and that he treated his name like a homonym. Apostrophizing himself with brief syllables, according to a cruelly calculated prosody of interjections, he then interposed himself, interjected himself, if I can say that, between himself and himself, so as to appeal desperately from himself to himself, in the sense in which one interjects an appeal after a judgment, which ought not to be the last. To be done—therefore—with judgment. He was evoking in these moments the violation of a tomb, which is what an art of cruelty must be, an anti-art, this "body of the old Artaud / buried / then unburied / by himself / outside eternities" (*OC* 14:42); "In face of all this what remains of the former Artaud? / Some notes" (*OC* 14:23). Or in still another example, one among so many, he opposed the false Christ who fled from Golgotha to the

"revolting death of the authentic tortured one on Golgotha (who was called Artaud like myself, and I do believe it was me)" (*OC* 14:43). Elsewhere, while in one notebook from 1946 one could read:

> oma
> noma
> hustling
> oneself
> primitive onomatopoeia . . .
> this onomatopoeia of the head,
> which I do not slip furtively into me
> but grab off the last roof . . .

on the facing page, as if in tête-à-tête, there was the interpellating auto-hetero-apostrophe:

> Artaud!
> How so Artaud?
> I had told myself never again to talk to myself,
> never.

(*oc* 24:386–87)

At a certain point these interjections were dictated. As if Artaud had not written but received them—which is what prophets do, they say. The interjections began with glossolalias, a kind of writing in language—as they say the prophets used to speak sometimes:

> **maloussi toumi**
> **tapapouts hermafrot**
> **emajouts pamafrot**

toupi pissarot

rapajouts erkampfti

It is not the crushing of the language but the hazardous pulverization [powder once again] of the body by ignoramuses. . . . no other orgy of spirits explains the constitution of things. . . . It's the farting of erotic gases from the place where it falls dead.

(*OC* 14:11)

A O, O A are not only vowels, thus fundamental voices. They are not only letters. They are interjections. I have never understood that one could love a museum. But also—this is a contradiction as unavoidable and as spectral as everything that is speaking here before us—I have never understood that one could love anything other than the grief-stricken Place, the taking-place, the event as event, already, of a future memory, the kept trace of doubled blows, a Museum, a Library, a Sepulchre, a Cemetery, a Sanctuary, a Temple, a Church, a Pyramid, a hieratic Archive, a Hierarchive that gives one as much to hear as to see.

What is a Museum, there where at the moment we think we are?

Moreover, is it possible, forever, *to be* ever *in* a museum that would be only a museum? Is beingness possible, that is, "êtreté" according to another of Artaud's neologisms, beingness *in* a museum? I am provisionally abandoning this immense question, but we are already lost in it because it is larger than we are. This question is an abyss that today I have the urge to nickname, quoting once again, the "Arto gulf" (A-r-t-o).

To substitute for that question another, which is more acute and literally more literal: what happens in a museum, in a museum of modern Art, when one vowel is replaced by another? When *O*

is revocalized as *A* in the interjected vociferation of a signature? When Momo becomes Moma? Or Momart? Perhaps the moment has then come to prepare for a second return of Artaud-Mômo.

Artaud-Mômo . . . Although in a drawing he called himself Saint Antonin, one day he also called himself, at least he recalled that he had been called Saint Tarto, T-a-r-t-o (*OC* 26:73), replacing thereby the *a* (*a-u-d*) that followed *art* by an *o*. Another persecuting permutation, here/there, there/here: O/A, fort/da, da/fort, Artaud.

I have been suffering for some months. I am suffering, yet I take pleasure in an obsession that I vaguely hoped to be rid of today: incessantly I hear him blaming me. Taking me to court and putting me on trial. Accuser and plaintiff, but always drawing, always in the process of drawing his lines, he would be indulging himself right here in what might be called *action-drawing*. Against me and against you as well. But for you it's something else, another story. Incessantly I project this scene and hear the voice of Artaud. I see nothing, I see no one, but I hear him. He cries out at me.

And time shifts into reverse. As if all my ritual visits to MoMA, for decades now, had been destined to the somewhat distracted inspection of these gallery places in view of preparing a solemn visitation, here, on a strange day, on the occasion of an anniversary. Not the visitation or visible apparition of Antonin Artaud in a temple of the visual arts; not the assumption of the revenant Artaud into the heaven of the New World or the great sperm bank of painting; not the abduction or kidnapping of Saint Artaud in this house of worship of modern art. No, rather the return of Artaud-Mômo, the specter of his voice whose body, by sacred

mission or commission, it would be my job to play at guarding for a moment, the bodyguard, right here, of a voice from beyond-the-grave and more alive than ever, as if I had been sent to occupy an impossible place on the American front by my friend Paule Thévenin (she from whom I would have sought advice and who would have said to me, from her very fresh grave, as she did one day in 1966, I will never forget, on the eve of a lecture on Artaud in Parma, during a university theater festival: "Jacques, go ahead, I cannot go myself, someone must respond to the invitation, I would rather it be you, one never knows what might happen with these professors he detested";[19] this time, she would have added, "especially over there, in America, where so many hippies and beatniks have also grabbed onto Artaud so they can indulge in a mimetic and identificatory gesticulation, some of them going so far, in their incredible anthology, as to attribute to him portraits of Gina Lollabrigida by a Czech neurotic! You know what the Americas were for him, for there is more than one, even in North America."[20] "What is more," she would have perhaps gone on to say, if I let her or made her speak, "as for you, you often go to America, you know it better than I do. Didn't you give your first American lecture in Baltimore, the very year of your lecture on Artaud in Parma? And didn't you go, on that occasion, to visit the ghost of Poe in his own house?" That's true, I would have said to her, and with these words I would have reminded her of a few pages in the "L'histoire vécue d'Artaud-Mômo." Written for the lecture at the Vieux Colombier, they situate once again, in a somewhat dreamlike geography, America, Baltimore, and Edgar Poe. America is not "big brother" but the "father-mother" of the "present world." I select from this "vision" only a few lines, but once again it is to invite you to reread it all:

> Conscience, conscience is easily said, conscience, as for me I have never figured out very well from which side to take hold of

that there cat, for the very good reason that it doesn't have one....
I'm pursued by a vision. I am in Baltimore on the bank of the Hudson, I haven't got a cent, I'm starving, drunk with rage against America I would like to checkmate it.

For it is America that for me now has become conscience.

Not mine, not that of a steer, a soul, a spirit, a body, an elephant, no,

the conscience of the present world, much more so than modern Soviet Russia, I think that it is truly America that holds this conscience, filtered, passed through the sieve and the sifter, the conscience of the present world,

which one?

that of the outside and the inside,

of the bottom, the background, the face,

of the surface of repression

or of that little hardened cyst on the gum of the inside,

for what are Americans?

Emigrants condemned by one world and who went and pitched their tent elsewhere....

they believed in their humanity,

the father-mother, the family, society, no god, no institutions of principle, no genesis, no atavistic cosmos, the atavism of the grandparents outside the world that holds you within,

in short all of democracy,

the commandment of the last to come,

the people, against things, god, and life,

I don't know whether a single authentic Puritan will recognize himself in this picture,

it is nonetheless the case that it was the mood of the first insurgents in America who were far, ultra-far from finding a people at their level,

today American conscience always wants the family, wants very much the society of families, and science to replace god....

Stirring these ideas about, on the banks of the Hudson, I felt myself reach the final limits of an impossible suffocation.

It is nevertheless you who suicided Edgar Poe because he did not conform to your idea of public freedoms, and man is his master but you were never his.

(OC 26:94–95)

The bodyguard of Artaud's voice—which I am not and do not wish to be but which I have perhaps acted for once—sees nothing but he lends an ear. Within earshot, I hear Artaud in his own tone launching invective, cursing, mocking or denouncing, blaspheming, swearing—and counterswearing, conjuring. Fulminating, thundering. Against everything: America, the United States of America, Art, the Museum, Modernity, MoMA. Especially MoMA in which Artaud the Mômo would have right away identified the malevolent figure of the great expropriator and the expert in curiosities of witchcraft, another "Museum of Magus Sorcerers and AL- / CHEMISTS." Right here today, I imagine, the eruption would have been volcanic; he would have yelled at you without consideration, he would have assaulted us with invective, he would perhaps have thrown imprecations in our face, while inventing them on the fly, unique and inimitable, unreproducible imprecations that would have been formed or deformed and meant for this place and this time, here, today, cruel glossopoetic interjections. Yes, let us keep this word *interjections,* because it at least passes between our two languages, in order to say how Artaud-Mômo would have attempted in his turn to interdict this manifestation, this exposition, this exhibition.

I impose on this word *interjection* a brief stasis so as to arrest two of its three meanings. I free it first of all—this is the contract I made with myself—from everything that leads it back toward

the semantic family of the jet, the jetty, ejaculation, the projection, the projectile—or the frenzied subjectile. Even though interjection has the meaning of a word or a piece of word, namely, the syllable or cry that one jettisons so as to shout in exclamation while interrupting the sense or the sentence or the other, even though one may be tempted to term interjections all of Artaud's poems, which come from no identifiable language and seem to send waves through his whole poetic oeuvre and all his drawings, let us direct the derivation of the word toward that which, in the language of the law, designates in the course of an *action*, that is, a lawsuit, the procedure of the appeal interjected when the injury and the injustice risk being authorized, then stabilized, and finally legitimated by an earlier judgment. One then interjects an appeal to put an end to the ill-judged thing, with a view toward rising up against the judgment of all judges, those of the Court, the Churches, the State, the Family, or Society, against the criterion of all those who take an oath and judge, all those who swear and conjure, who criticize, evaluate, diagnose: doctors, especially psychiatrists, art critics, literary critics, moralists and priests, professors, all secretly warranted by some judgment of god with which the final interjection would like to have done. Through the counterdemonstration of a prosecutor's-defense attorney's final argument and of a counterinitiate's counterconjuration on appeal, Artaud-Mômo, Artaud the madman-child, Mômo the kid (*le môme*), would have with his own voice and his whole body protested so as to interrupt, interpose himself, interject himself in appeal against so many indictments: for another himself whose blows and wounds, whose electrocuted body and barely cauterized scars we are keeping here. It so happens, precisely in *Interjections* (as always, a thoroughly elaborated text in the very launching of its irrepressible jet), that Artaud replaced the word *coup* by the word *corps* (body) twice in a row, as if it were more or less the

same thing, a synonym and almost a homonym (*OC* 14:12, 251*n*12). Elsewhere he lets them double each other and reverberate in each other:

OF THE BODY,
no fear,
<u>no impressions</u>,
OF THE BODY,
OF THE BLOWS,
OF THE BLOWS,
of individuality . . .

(*oc* 14:162–63)

[DU CORPS,
pas de peur,
<u>pas d'impressions</u>,
DU CORPS,
DES COUPS,
DES COUPS,
de l'individualité . . .]

I had to begin by listening, by playing for you so you could hear in his own language and according to his voice the merciless complaints of Antonin Artaud, these grievances and these imprecations. These interjections. First of all because never before, when finding myself faced with drawings or paintings, although unable to face them, never have I heard so many voices, never have I felt myself called, yelled at, touched, provoked, torn apart by the incisive and lacerating acuteness of a broadside of interjections so justly adjusted to their addressee. As if, first of all, they were addressing me so as to conduct my trial. Never, for me at

least, will the paper support of a work of visual art, as you say here, have been perforated, never will it have been consumed by the inflamed signature of such an incontestable voice.

Poor Artaud who said one day:

No.
I did not know what I would suffer.
And now enough and for all time.
You will judge no more.

(OC 26:34)

Poor Artaud. What is happening to him! He will have been spared nothing, this Mômo. Nothing. Not even the survival of his specter, not even the most equivocal, and cruelly ambiguous, the most vain and most anachronistic revenge.

AFTERWORD

KAIRA M. CABAÑAS

By the time of his lecture on the exhibition of Antonin Artaud's drawings at the Museum of Modern Art in October 1996, Jacques Derrida had published a few essays on Artaud, the "La parole soufflée" (1965) and "The Theater of Cruelty and the Closure of Representation" (1966).[1] But it is with "To Unsense the Subjectile" (1986) that Derrida first engages Artaud's drawings and portraits, offering a meditation on the "coming-to-be" of Artaud's untranslatable concept of the *subjectile*: as that which underlies both language and art, as support and surface, as above and below, and as something that is not representable.[2] Derrida describes Artaud's continual bodily struggle with language, his writing-drawing (written drawings), as well as his resistance to describing works of art. In fact, Artaud preferred to call his visual work "documents." Echoing Artaud, Derrida affirms, "We won't be describing any paintings," for to do so would be to circumscribe their effects within the realm of representation that Artaud continually raged against.[3] *Artaud the Moma* shares the earlier text's meditation on art and subjectivity, drawing and writing, and similarly offers an extended analysis of Artaud's portraits and drawings, a probing account of an admittedly challenging corpus.

Beyond what *Artaud the Moma* provides as a model for thinking the relation between writing and drawing and the performative force of Artaud's work, the lecture also serves as an important historical record, one that summons the challenge that Artaud posed to Derrida and, through him, to the museum and to art history. Hence the most significant difference between *Artaud the Moma* and the earlier "To Unsense the Subjectile" is Derrida's consideration of the institutional frame: what it meant for the Museum of Modern Art to exhibit Artaud's drawings and for him to speak of the drawings in that context in 1996.[4] As Derrida makes clear, the "Moma" in the work's title evokes both the museum and Artaud's return to Paris as "Mômo" in 1946 after nine years of internment in various asylums throughout France. Derrida reminds us that at different moments Artaud referred to himself as Satan, as the Antichrist, as le Mômo, and as Artaud-Mômo. With the multiplicity of the figure that he traces, Derrida stages a challenge to the modernist museum's premium on originality and singularity. Insofar as Derrida introduces the question of the museum frame, he also tasks himself with describing the singularity of Artaud's *coup*, or blow, as the means by which—through violent marks, literal burns on the support, and what he called "deliberately botched" drawings—he waged against reproduction and all institutional appropriations, be it the family or the museum. The force of Artaud's language derives not from the successful fulfillment of conventions but from a dogged attempt to embody language in gesture, to harness graphic traces toward performative ends. Derrida resuscitates the cruel singularity of Artaud's *coup* to in turn "cruelly expose, I mean exhibit this [MoMA] exhibition." That the work's blow was not exhausted in the act and paradoxically survives as traces on a support that can be on display leads Derrida to declare that "this salvation also means loss" and how this loss is "no doubt the cruelest fate of the cruelty out of which Artaud will have made his theater."

It is the contradiction between the singularity of the blow and its double status as act and trace that drives much of the lecture. Derrida's account of Artaud's redoubled blow also derives further impact from the historical and biographical fact that Gaston Ferdière, Artaud's psychiatrist, administered electroshock therapy to him. But Ferdière was also an advocate of his patients' art: Ferdière collected their work, exhibited it, and also loaned it to surrealist exhibitions, and even claimed himself to be the inventor of art therapy. By 1946 he had assembled a notable collection and tried to persuade Artaud to include his drawings in the *Exposition d'œuvres de malades mentaux* (Exhibition of works by the mentally ill) at the Centre psychiatrique Sainte-Anne, which included works culled from his collection. Although he was under Ferdière's care at the time, Artaud's drawings were not exhibited, even though it was precisely in the clinical context that Artaud returned to drawing.[5]

Upon Artaud's release from the psychiatric asylum in Rodez and return to Paris in May 1946, artist Jean Dubuffet voluntarily presided over the Société des Amis d'Antonin Artaud. The society sponsored a series of events that framed Artaud's return to Parisian social life, including the exhibition of Artaud's drawings at the Galerie Pierre in 1947 (the only exhibition of his drawings during his lifetime; many of which were included in the 1996 MoMA exhibition). Dubuffet rejected not only the association of Artaud's work with psychopathological studies, and thus the exhibition taking place at Sainte-Anne, but also the association of Artaud's work with his collection of Art Brut, of which some of the objects had been made by psychiatric patients. He writes: "I find Antonin Artaud very cultured, not at all Art Brut."[6] And while Dubuffet echoed Artaud's refusal to have his drawings inscribed within a psychiatric context, as Denis Hollier explains, such a stance "did not prevent reviewers and critics from mentioning Artaud's stay in mental institutions every time they referred

to him for years to come."[7] The year of his exhibition, Artaud also entered the debate on the relation between art and madness with the publication of his slim volume *Van Gogh le suicidé de la société* (Van Gogh: The man suicided by society, 1947), a vitriolic critique of psychiatric practice that also offers some of the most precise formal and materialist readings of Vincent van Gogh's paintings. Artaud describes how society invented psychiatry "to defend itself against the investigations of certain superior lucidities" and poses the question "what is a genuine lunatic?" To which he responds "a man whom society has not wanted to heed and whom it has wanted to keep from uttering unbearable truths." He affirms that it is not "conformisms of manners and morals that Van Gogh's painting attacks but those of institutions themselves."[8]

Yet if Van Gogh attacked institutions, it was not by means of what his paintings represent but rather *how* he paints. For Artaud: "Van Gogh will prove to have been the most utter painter of all painters, the only one who did not want to go beyond painting as the strict means of his work and the strict frame of his means"; "A painter, nothing but a painter, Van Gogh took hold of the means of pure painting and he did not go beyond them"; "this painter who is only a painter, and who is more of a painter than the other painters, as if he were a man in whom the material, the paint, has a place of prime importance"; "this painter who is nothing but a painter is also the one painter of all the painters born who makes us most forget that we are dealing with painting."[9] It is a text in which Artaud, as in the conclusion to his censored radio program *Pour en finir avec le jugement de Dieu* (*To Have Done with the Judgment of God*, 1948), also inscribes his own subjectivity and historical circumstances: "I will never again, *without committing a crime,* tolerate hearing anyone say to me: 'Monsieur Artaud, you're raving,' as has so often happened to me."[10]

By the time of his final interview on February 28, 1948, Artaud confessed, "I have been haunted for so long, *haunt-ed* by a kind of writing that is not the norm. I would like to write outside of grammar, to find a means of expression beyond words. And I occasionally believe that I am very close to that expression . . . but everything pulls me back to the norm."[11] Artaud continually struggled against the appropriation of his speech, even when the voice of the body, his body as a ghost, continually returns through his recorded voice in *Pour en finir avec le jugement de Dieu*. It is Artaud's recorded voice that can be heard when one listens to the recording of Derrida's lecture in MoMA's archive; it was played at the lecture's beginning and end. Listening to the lecture at a more than a twenty-year temporal remove, one notes how *Artaud the Moma*'s tour de force arrives at the lecture's conclusion. Derrida conjures a scene, one in which he imagines being haunted by Artaud's specter when writing the lecture. He also describes how he could not stop thinking about Artaud listening to what he was going to say at the museum: "Right here today, I imagine, the eruption would have been volcanic; he would have yelled at you without consideration, he would have assaulted us with invective, he would perhaps have thrown imprecations in our face." Derrida places Artaud's specter at the scene of writing, but also, through the recording, at the scene of his lecture at MoMA and his address to the audience.

The stakes of this redoubled spectrality are further put in relief when one considers how Artaud, when publishing *Van Gogh le suicidé de la société*, engaged in a near complete identification with the painter so as to portray Van Gogh's practice independent of his clinical biography but also inscribe therein his own relation to art, society, and psychiatry. In contrast, Derrida's engagement with Artaud is marked by an admiration, but also a profound disidentification. As if in mirrored inversion to the Artaud–Van

Gogh association, Derrida describes his relation with Artaud as one of a "reasoned detestation," an "essential antipathy," granting Artaud the status of his "privileged enemy." Yet Derrida's antipathy, which he confesses he had harbored for over thirty years, also entails an *alliance*. He explains that before blaming Artaud for his metaphysical rage one must: "lay blame on a machination, on the social, medical, psychiatric, judicial, ideological machine, on the machine of the police . . . on a philosophical-political network that allied itself with more obscure forces so as to reduce this living lightning to a body that was bruised, tortured, rent, drugged, and above all electrocuted by a nameless suffering, an unnamable passion to which no other resource remained than to rename and reinvent language."

Almost forty years after their debate on madness began, Derrida's ethical turn to the machinations of a philosophical-political network echoes the earlier work of his other "enemy": Michel Foucault. Much ink has been spilled on the exchange between Derrida and Foucault around the latter's publication of *The History of Madness* (1961).[12] In this context, I would like to recall, albeit briefly, that, at the time, the primary issue for Derrida was not that madness was expulsed during the Classical Age, but that madness is *always already* internal to reason. For Derrida, Foucault isolated madness while nonetheless claiming to make it speak for itself. In "Cogito and the History of Madness" Derrida affirms how nothing can escape this language of reason that Foucault aimed to put on trial. He observes how such a trial would be impossible given how "the articulation [of] the proceedings and the verdict unceasingly reiterate the crime."[13] That is, Foucault repeats the initial act of separation his book aims to trace. He silences the silences he hopes to reveal.

What I would like to draw attention to here, to the degree that it is a passage that finds resonance in *Artaud the Moma*, is

how when speaking of the work of art Foucault holds at bay an artist's madness to instead speak of a historic reversal inaugurated by the work of figures such as Vincent van Gogh and Antonin Artaud. Foucault writes, "Henceforth and through the mediation of madness, it is the world that becomes guilty . . . in relation to the œuvre: it is now arraigned by the œuvre, constrained to speak its language, and obliged to take part in a process of recognition and reparation, to find an explanation *for* this unreason, and *explain itself* before it."[14] Here painting reveals neither the truth of madness nor the truth of reason but serves as a medium through which to challenge reason's silencing of madness. It follows that such paintings put us on trial.

To counter the silence of MoMA's galleries and the visual language of its display, Derrida allied himself with Artaud, his written drawings, and literally channeled his speech. In the course of the lecture, Artaud appears as a kind of conflagration, as a "dangerous, mortal, exceptional lightning" that seeks to engage "a history of art whose concept he will have sought to attack and virtually destroy." But, for Derrida, Artaud's relentless struggle against representation, against masterpieces, against artistic and all filiations is indissociable from the philosophical-political network that reduced his force to a mere sign to be classified and archived. Derrida's lecture extends from the historical philosophical-political network to the contemporary "crime" committed against Artaud by the art-institutional frame. He holds the museum's expropriations accountable; it mummifies and classifies, assimilates Artaud's work to its language and categories, consequently taming the work's performative force. To be sure, Derrida accounts for the singularity of the blow, all the while attentive to its paradoxical survival, a survival upon which its taming in the space of the museum unwittingly depends.

When faced with such works, such blows, Derrida implicitly asks what kind of viewers Artaud's drawings call upon us to be. It is not an innocent question, and it is a question with particular critical purchase today, for which we owe a debt to Artaud, to Derrida, as well as to their ghosts. While Artaud's work may have been denied status as Art Brut, the relevance of Derrida's lecture from the perspective of art history and criticism could be extended, I argue, beyond Artaud and to the recent trend to include modern psychiatric patients' work in global art biennials. Often the inclusion of outsider art is read as a progressive move within the modern and/or contemporary art institution, and in the early 2010s one witnesses how the art of "madness," "outsider," and "self-taught," became the "new" in the contemporary global circuit and included in exhibitions that turned to *beauty*, the *poetic*, and *imagination* as unifying themes. In these contexts the work of outsider artists, many of them individuals who had experienced psychic suffering and created their work in the context of an asylum, are legitimated within the contemporary art system. Yet this legitimation, which is also an assimilation of the work to the language of art history and its formal categories and thus a silencing of the work's original meanings and values, occurs at the expense of what we might learn from the specificity of the work's contemporaneity vis-à-vis the historicity of the psychiatric institution—that is, the very modern philosophical-political network that aimed to separate psychiatric patients and their madness from the world.[15] In the face of the social, commercial, ideological, and global curatorial network that has expanded to uncritically incorporate such work, and in which "madness" appears as the system's final frontier, perhaps we should revisit Artaud's query, which was nestled at the border of the face depicted in *Portrait of Jany de Ruy* (1947) and with which Derrida's *Artaud the Moma* begins: "*And who / today will say / what?*"

NOTES

PREFACE

1. The present translation is published without illustrations. The references for the reproduced works are to two sources: Jacques Derrida and Paule Thévenin, *Antonin Artaud: Dessins et portraits* (Paris: Gallimard/Munich: Schirmer/Mosel, 1986); and Margit Rowell, ed., *Antonin Artaud: Works on Paper* (New York: Museum of Modern Art, 1996).

ARTAUD THE MOMA

1. Antonin Artaud, *Œuvres complètes*, 14 (Paris: Gallimard, 1978), 86. Henceforth references to this edition will be given in parentheses in the text as *OC* followed by volume and page numbers.
2. See Jacques Derrida, "Faith and Knowledge: The Two Sources of 'Religion' at the Limits of Reason Alone," trans. Samuel Weber, in Jacques Derrida, *Acts of Religion*, ed. Gil Anidjar (New York: Routledge, 2002), 40–101.
3. Antonin Artaud, "Dix ans que le langage est parti," in *Luna-Park* 5 (Brussels, 1979).
4. Paule Thévenin, "Entendre/voir/lire," in *Antonin Artaud, ce désespéré qui nous parle* (Paris: Seuil, 1993), 238.
5. "Here lies" ("Ci-Gît"), trans. Clayton Eshleman and Bernard Bador, in *Watchfiends and Rack Screams* [*Suppôts et suppliciations*] (Boston: Exact Change, 1995), 193 (translation modified).

6. Thévenin, "Entendre/voir/lire," 238.
7. A part of this diary was published with the title *En compagnie d'Antonin Artaud* (Paris: Flammarion, 1974).
8. See Paule Thévenin's note, in Jacques Derrida and Paule Thévenin, *Artaud: Dessins et portraits* (Paris: Gallimard, 1986), 266.
9. See Jacques Derrida, "Forcener le subjectile," ibid.
10. *Portraits et dessins par Antonin Artaud* (Paris: Galérie Pierre, 1947).
11. June 1947, manuscript version copyright © Gallimard, quoted in *Antonin Artaud: Dessins* (Paris: Centre Georges Pompidou, 1987), 44.
12. *OC*, which assembles all these texts, 212.
13. The "counterblow," merely a "counterblow" is, moreover, how Artaud defines his "feelings" in an extraordinary passage of *L'histoire vécue d'Artaud-Mômo* that one would have to analyze word for word: "My feelings are merely the counterblow of an old clash of bones, an organic tearing, / moreover I know nothing about it and I no longer want to know it, / I want to know absolutely nothing any longer, / I feel pain from everything and I've had enough, / and I think that thinking must disappear." The following page protests (therefore) against the very frequent suspicion of *mysticism*, and does so in the name of the being-present of what is (present) but as "present nothingness." The "Shit to that" that punctuates the declaration of war takes on its full meaning of "shit to ontology" as "shit to mysticism": "I who do not believe in the spirit... and who do not believe in consciousness... I who want the body to live without haste, without end... I'm supposedly a mystic? Shit / to that. / Finally I cannot be *a mystic* because I believe only in what is and not in what will be... and I have never considered the future, / but the immediate and present nothingness, / my present body... beating, annihilating, and creating in the present nothingness" (*OC* 2:40–41).
14. "Le visage humain" (end of June 1947), in *Antonin Artaud: Dessins*, 50 (emphases added).
15. On this episode and its probable context, see *OC* 14:137.

 The translation of this and subsequent transcriptions of the *Sorts* do not attempt to represent the destruction of parts of words.—TRANS.
16. For example, but it would be necessary to read and reread the whole dossier of Artaud the Mômo, up to the haunting as denial of haunting (the "this is not just" of the denial) and the sarcasms against the archivist-collector-amateur of sperm: "If I wake up every morning with a frightful smell of come around me, it's not because I've been succubused all

night by golems, specters, vampires, angels, and spirits from the fucking rubbish heap of a beyond, but because men from this

> world and not from the other give each other the signal in their 'perisprit'
> rubbing of their full balls on the canal of their well-rubbed and well-grabbed
> anus,
> so as to pump out my life.
> Your sperm is very good, a cop at the Dôme said to me one day in the tone of a dilettant taster..."

17. Werner Hamacher, "Expositions of the Mother: A Quick Stroll Through Various Museums," in Thomas Keenan, ed., *The End(s) of the Museum* (Barcelona: Fundació Antoni Tàpies, 1996).
18. He names Heidegger in this passage: "this unheard-of problem: it is Arthur Adamov, the same one, who posed it for the first time. On another level than Dostoievsky, Kafka, Kierkegaard, Heidegger, and above them all, from a distance, that lady, newly come before Jesus-Christ, / two thousand years before Jesus-Christ, that is called illness..." (October 10, 1946, *OC* 24:65).
19. These belong to the "sect of the innumerable necrophages that fill churches, police stations, army barracks, prisons, hospitals, university faculties, laboratories, and insane asylums, / priests, rabbis, brahmins, imams, lamas, bonzes, popes, pastors, cops, doctors, professors, and scientists, / and now the sacrosanct institutions, the sacrosanct laws..." This long indictment (that must be read *in extenso*) rejects—or reduces thus to the same conspiracy, to its single principle—every other theory, every other politics, every other other knowledge, that of Freudian psychoanalysis in particular (*OC* 2:33 ff.).
20. See Antonin Artaud, *Anthology*, ed. Jack Hirschman (San Francisco: City Lights, 1965), 102–4.

AFTERWORD

1. See "La parole soufflée" (1965) and "The Theater of Cruelty and the Closure of Representation" (1966), in *Writing and Difference*, trans. Alan Bass, 2d ed. (London: Routledge, 2001), 212–45, and 292–316. The MoMA

archival record dates the lecture Thursday, October 10, 1996. Derrida dates it October 16, 1996.
2. Jacques Derrida, "Forcener le subjectile," in Paule Thévenin and Jacques Derrida, *Antonin Artaud: Dessins et portraits* (Paris: Gaillimard, 1986), 55–108; "To Unsense the Subjectile," in *The Secret Art of Antonin Artaud*, trans. Mary Ann Caws (Cambridge: MIT Press, 1998), 60–157.
3. "To Unsense the Subjectile," 71.
4. Derrida returns to the subject of his lecture in interview in 2001. See Évelyne Grossman, Entretien avec Jacques Derrida, "Artaud, oui . . . ," *Europe* 873–74 (January–February 2002): 23–38.
5. See the discussion in Denis Hollier, "The Artaud Case. Part 2: The Case History," in *Specters of Artaud: Language and the Arts in the 1950s*, ed. Kaira M. Cabañas (Madrid: Museo Nacional Centro de Arte Reina Sofía, 2012), 236; and Sylvère Lotringer, "Who Is Doctor Ferdière," in his *Mad Like Artaud*, trans. Joanna Spinks (Minneapolis: Univocal, 2015 [2003]), 129–30.
6. Jean Dubuffet to Roger Caloni, September 27, 1968, reproduced in *Artaud et l'asile 2: Le cabinet du docteur Ferdière*, ed. Laurent Danchin (Paris: Nouvelles Éditions Séguier, 1996), 115 (my translation).
7. Hollier, "The Artaud Case," 236. Hollier's statement also applies to the reviews of the MoMA exhibition. See, for example, Donald Kuspit, "'Antonin Artaud: Works on Paper' (insane artist)," *Artforum International* 35, no. 5 (January 1997): 80+.
8. Antonin Artaud, "Van Gogh: The Man Suicided by Society" (1947), in *The Trembling Lamb: Antonin Artaud, Carl Solomon, LeRoi Jones* (New York: 1959), 2–4 (translation modified).
9. Ibid., 15–17.
10. Ibid., 22 (emphasis added).
11. Jean Desternes, "Dernière visite à Antonin Artaud," in *Le Figaro littéraire*, March 13, 1948, 3.
12. Michel Foucault, *The History of Madness*, trans. Jonathan Murphy and Jean Khalfa (New York: Routledge, 2006 [1961]). To Derrida's "Cogito and the History of Madness" (1963), Foucault responded with "My Body, This Paper, This Fire" (1972), reproduced in *The History of Madness*, 550–74. Derrida responded in turn with "'To Do Justice to Freud': The History of Madness in the Age of Psychoanalysis" (1992), published on the occasion of a volume to commemorate the thirtieth anniversary

of Foucault's work. Published in English in *Critical Inquiry* 20, no. 2 (Winter 1994): 227–66. For a critical engagement with the Foucault-Derrida debate on madness, see, for example, Shoshana Felman, "Madness and Philosophy or Literature's Reason," in *Yale French Studies*, no. 52, Graphesis: Perspectives in Literature and Philosophy (1975): 206–28; and Roy Boyne, *Foucault and Derrida: The Other Side of Reason* (New York: Routledge, 1990).

13. Derrida, "Cogito and the History of Madness," 41–42.
14. Foucault, *The History of Madness*, 537.
15. Psychiatric patients' work was exhibited in the specific cases of the Eleventh Lyon Biennial (2011), the Thirtieth Bienal de São Paulo (2012), and the Fifty-fifth Venice Biennale (2013). This global turn to outsider art and the art of modern psychiatric patients also often perpetuates an anachronistic approach to the psychiatric institution that does not address changes in psychiatric practice. For example, *The Encyclopedic Palace* (the Fifty-fifth Venice Biennale) upheld an ahistoricized notion of inner vision and at the same time failed to account for critiques of psychiatric authority. In the biennial host country, such an evasion seemed particularly glaring given the central role of Italian Franco Basaglia in the antipsychiatric and deinstitutionalization movement of the 1960s and 1970s. I take up this subject in chapter 5 of my forthcoming book, "Learning from Madness: Brazilian Modernism and Global Contemporary Art."

ACKNOWLEDGMENTS

KAIRA M. CABAÑAS

Marguerite Derrida and Éditions Galilée graciously agreed to this English translation of the French *Artaud le Moma* (2003). Peggy Kamuf, Derrida's trusted translator, deserves special credit for her careful work on this volume. What is more, Kamuf was no stranger to the text: she translated the original lecture and was present when Jacques Derrida delivered it at the Museum of Modern Art in New York in 1996. At Columbia University Press, I would like to thank publisher Wendy Lochner for her enthusiasm and backing of the project, as well as the Press's excellent editorial staff. I am further grateful to two anonymous reviewers who supported the translation.

Artaud the Moma and my work as editor benefited from subvention support from the University of Florida College of the Arts and Center for the Humanities and the Public Sphere (Rothman Endowment). With regard to my afterword, Jesús Fuenmayor, Rachel Silveri, and graduate students in my Critical/Clinical/Curatorial seminar at the University of Florida provided feedback on an early version, while Peggy Kamuf, Denis Hollier, and an anonymous reader for Éditions Galilée endorsed its final form. Finally, I must single out art historian Branden W. Joseph

for first drawing my attention to Derrida's lecture on Artaud's drawings and to its unpublished status in English. Thank you, Branden, for encouraging me to pursue this publication and for giving me an opportunity to bring back another specter.

Lydia Goehr and Daniel Herwitz, eds., *The Don Giovanni Moment: Essays on the Legacy of an Opera*

Robert Hullot-Kentor, *Things Beyond Resemblance: Collected Essays on Theodor W. Adorno*

Gianni Vattimo, *Art's Claim to Truth,* edited by Santiago Zabala, translated by Luca D'Isanto

John T. Hamilton, *Music, Madness, and the Unworking of Language*

Stefan Jonsson, *A Brief History of the Masses: Three Revolutions*

Richard Eldridge, *Life, Literature, and Modernity*

Janet Wolff, *The Aesthetics of Uncertainty*

Lydia Goehr, *Elective Affinities: Musical Essays on the History of Aesthetic Theory*

Christoph Menke, *Tragic Play: Irony and Theater from Sophocles to Beckett,* translated by James Phillips

György Lukács, *Soul and Form,* translated by Anna Bostock and edited by John T. Sanders and Katie Terezakis with an introduction by Judith Butler

Joseph Margolis, *The Cultural Space of the Arts and the Infelicities of Reductionism*

Herbert Molderings, *Art as Experiment: Duchamp and the Aesthetics of Chance, Creativity, and Convention*

Whitney Davis, *Queer Beauty: Sexuality and Aesthetics from Winckelmann to Freud and Beyond*

Gail Day, *Dialectical Passions: Negation in Postwar Art Theory*

Ewa Płonowska Ziarek, *Feminist Aesthetics and the Politics of Modernism*

Gerhard Richter, *Afterness: Figures of Following in Modern Thought and Aesthetics*

Boris Groys, *Under Suspicion: A Phenomenology of the Media,* translated by Carsten Strathausen

Michael Kelly, *A Hunger for Aesthetics: Enacting the Demands of Art*

Stefan Jonsson, *Crowds and Democracy: The Idea and Image of the Masses from Revolution to Fascism*

Elaine P. Miller, *Head Cases: Julia Kristeva on Philosophy and Art in Depressed Times*

Lutz Koepnick, *On Slowness: Toward an Aesthetic of Radical Contemporaneity*

John Roberts, *Photography and Its Violations*

Hermann Kappelhoff, *The Politics and Poetics of Cinematic Realism*

Cecilia Sjöholm, *Doing Aesthetics with Arendt: How to See Things*

Owen Hulatt, *Adorno's Theory of Philosophical and Aesthetic Truth: Texture and Performance*

James A. Steintrager, *The Autonomy of Pleasure: Libertines, License, and Sexual Revolution*